ART OF CENTRAL AFRICA

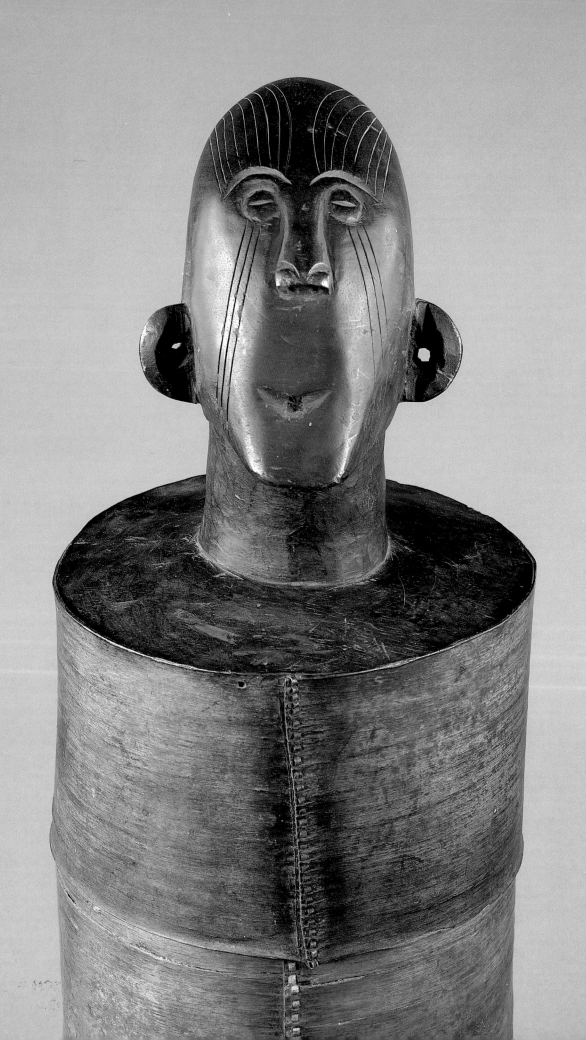

ART OF CENTRAL AFRICA

Masterpieces from the
Berlin Museum für Völkerkunde

Hans-Joachim Koloss

The Metropolitan Museum of Art
Distributed by Harry N. Abrams, Inc.
New York

This publication was issued in connection with the exhibi-
tion *Art of Central Africa: Masterpieces from the Berlin Museum
für Völkerkunde* held at The Metropolitan Museum of Art
from June 6 through November 4, 1990.

Published by The Metropolitan Museum of Art, New York

John O'Neill, Editor in Chief
Barbara Burn, Project Supervisor
Martina D'Alton, Editor
Russell Stockman, Translator
Michael Shroyer, Designer
Peter Antony, Production

Library of Congress Cataloging-in-Publication Data

Koloss, Hans-Joachim, 1938–
 Art of Central Africa : masterpieces from the Berlin
Museum für Völkerkunde / Hans-Joachim Koloss.
 p. cm.
 Includes bibliographical references.
 ISBN 0-87099-590-1. — ISBN 0-8109-2462-5
 (H.N. Abrams)
 1. Art, Black—Africa, Central—Exhibitions. 2. Art,
Primitive—Africa, Central—Exhibitions. I. Museum
für Völkerkunde (Germany : West) II. Metropolitan
Museum of Art (New York, N.Y.) III. Title.
N7391.65.K65 1990
730'.0967'0747471—dc20 90-5898
 CIP

Composition by U.S. Lithograph, typographers, New York
Printed by Mercantile Printing Company, Worcester, Mass.
Bound by J.S. Wesby and Company, Worcester, Mass.

The photographs reproduced in this book unless otherwise
credited were provided by the Museum für Völkerkunde,
Berlin.

On the front of the cover: Standing Male Figure
(Zaire; Hemba. cat. no. 54)
Frontispiece: Container, detail (Zaire; Mangbetu.
cat. no. 58)

Contents

Foreword

The Museum für Völkerkunde in Berlin is one of the world's foremost museums of anthropology, and the art of Central Africa is only one of the many strengths of its extensive African holdings. Although these important works have long been known and admired by scholars and collectors of African art through the museum's comprehensive program of publications, they have only occasionally been on public display in its galleries since 1945. The Metropolitan Museum of Art is therefore pleased to present an exhibition of the highlights of the Museum für Völkerkunde's collection of Central African sculpture.

The Museum für Völkerkunde is now part of the comprehensive seven-museum complex of the Staatliche Museen Preussischer Kulturbesitz in Dahlem, West Berlin. The museum was formed in the 1870s and 1880s, decades that saw the creation of many of the world's premier museums of art, natural history, and anthropology. In contrast, The Metropolitan Museum of Art acquired its first African sculpture in 1950, and the Museum of Primitive Art, whose collection merged with ours in 1978 and 1979, was founded in 1954. Thus, the African collection at the Metropolitan Museum was not begun until more than seventy years after the creation of the Museum für Völkerkunde in Berlin, and consequently it is vastly different in size and scope. Central Africa in particular is one of the areas in which our own collection is not as rich. We are, therefore, all the more fortunate, thanks to the generosity and cooperation of the Berlin Museum für Völkerkunde, to be able to present a more complete view of Central Africa's major sculptural traditions to our visitors.

I would like to express my gratitude to Professor Dr. Wolf-Dieter Dube, Director General of the Staatliche Museen Preussischer Kulturbesitz. He took the initiative in proposing this exhibition, and his continued support at every stage helped bring it to fruition. My gratitude extends as well to Professor Dr. Klaus Helfrich, Director of the Museum für Völkerkunde, for his enthusiastic commitment to this exhibition. I am also pleased to acknowledge the contribution of Dr. Hans-Joachim Koloss, Director of the Africa Department at the Museum für Völkerkunde. He was responsible for the exhibition *Zaïre: Meisterwerke afrikanischer Kunst*, which was shown in Berlin in 1987 and formed the basis for the present exhibition. Dr. Koloss wrote the introduction to this catalogue and, with Dr. Kate Ezra, Associate Curator in the Department of Primitive Art at the Metropolitan Museum, selected the works to be shown in New York. In addition, Dr. Ezra served as coordinator for this publication.

I am also deeply grateful to the Federal Council on the Arts and Humanities for granting the Metropolitan Museum a United States Government Indemnity for this exhibition.

The sculptures included in the exhibition have never before been shown in the United States. The Metropolitan Museum of Art is honored to have been entrusted with these masterpieces of African art and is grateful for the opportunity to present them to the American public.

Philippe de Montebello
Director, The Metropolitan Museum of Art

Acknowledgments

Many people have contributed their special knowledge and skills to the realization of this exhibition and its catalogue, and we would like to express our gratitude to them all. In particular we would like to thank the scholars whose insights into the art of Central Africa are evident in the catalogue entries they have written: David Binkley, Nelson-Atkins Museum of Art; Arthur Bourgeois, Governor's State University; Kathy Curnow, University of Pennsylvania; Dunja Hersak, Université Libre de Bruxelles; Wyatt MacGaffey, Haverford College; Polly Nooter, National Museum of African Art; and Enid Schildkrout, American Museum of Natural History. We would also like to acknowledge our profound gratitude to Albert Maesen, of the Musée Royal de l'Afrique Centrale, Tervuren, who provided much valuable information about many of the objects included in the exhibition. Leon Siroto also shed light on some difficult problems.

A special word of thanks goes to Martina D'Alton, who adroitly edited and shaped this publication, and to Michael Shroyer, who designed it. Our gratitude also extends to the many others in New York whose diverse talents contributed to the success of the project: Michael Batista, John Buchanan, Barbara Burn, Ross Day, Marguerite de Sabran, Jim Dowtin, Ellen Howe, Nina Maruca, Joan Anne Maxham, Nancy Reynolds, Don Roberts, Cynthia Turner, Kerstin Volker, Jean Wagner, Sandy Walcott, and Alexa Wheeler. At the Museum für Völkerkunde in Berlin, we would like to acknowledge the excellent photographic skills of Waltraut Schneider-Schütz, as well as the dedicated work of Olaf Helmcke, conservator, and Andreas Wilczek.

Our deepest appreciation is extended to all.

Kate Ezra
Hans-Joachim Koloss

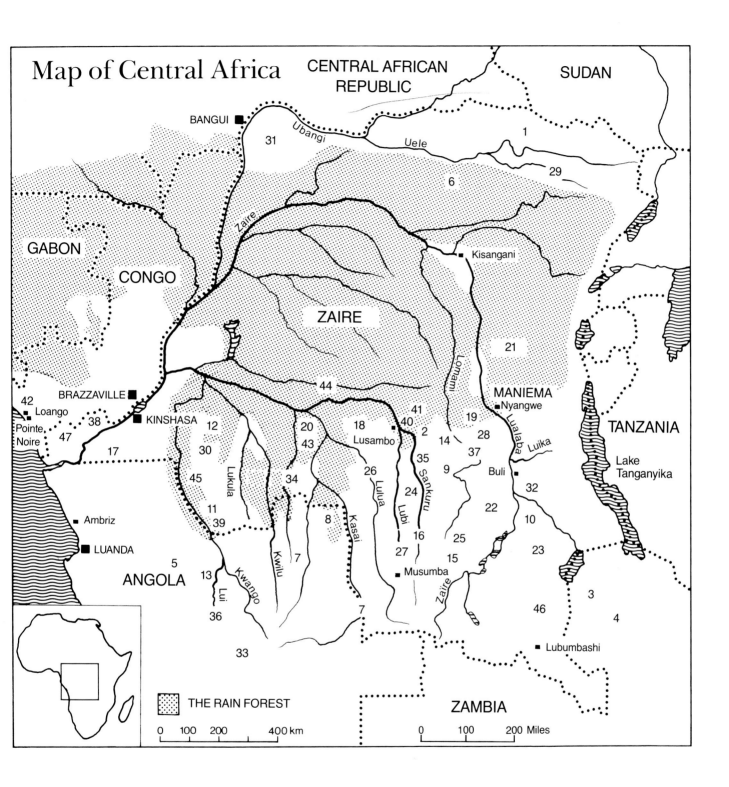

Map of Central Africa

Ethnic Groups

1. Azande	9. Eki	17. Kongo	25. Luba-Shankadi	33. Ovimbundu	41. Tetela
2. Bala	10. Hemba	18. Kuba	26. Lulua	34. Pende	42. Vili
3. Bemba	11. Holo	19. Kusu	27. Lunda	35. Sanga	43. Wongo
4. Bisa	12. Hungaan	20. Leele	28. Malela	36. Songo	44. Yaelima
5. Bondo	13. Imbangala	21. Lega	29. Mangbetu	37. Songye	45. Yaka
6. Bua	14. Kalebwe	22. Luba	30. Mbala	38. Sundi	46. Yeke
7. Chokwe	15. Kalundwe	23. Luba-Hemba	31. Ngbaka	39. Suku	47. Yombe
8. Dinga	16. Kanyok	24. Luba-Kasai	32. Niembo	40. Tempa	

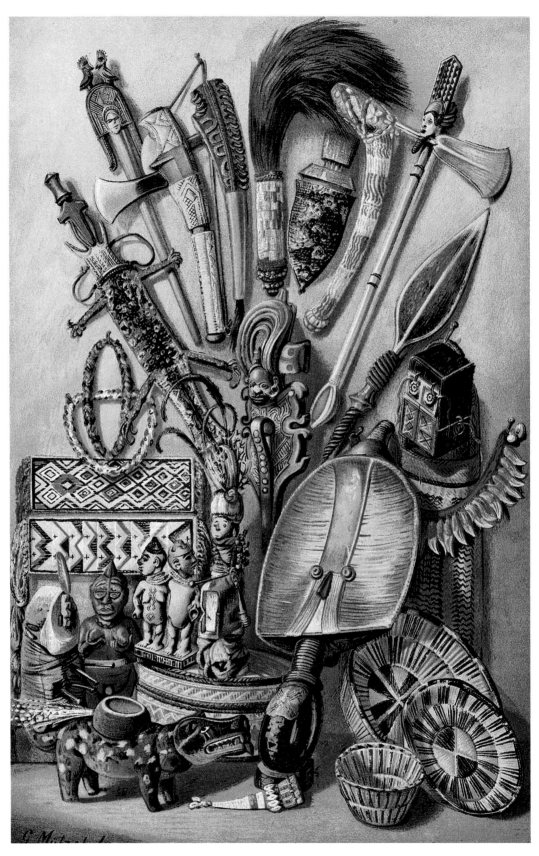

Fig. 1. An array of Central African sculptures, weapons, ornaments, and implements, mostly from the Berlin Museum für Völkerkunde (from Ratzel 1887, 1: pl. opp. 590). Seen in the center of this grouping is the Chokwe staff (cat. no. 36) which entered the Berlin museum's collection in 1875. Friedrich Ratzel, originally trained as a geographer, became one of the most influential figures in German anthropology in the late nineteenth century. (Photograph courtesy of the Robert Goldwater Library and Photo Studio, The Metropolitan Museum of Art).

Introduction

Hans-Joachim Koloss

Art of Central Africa and the Berlin Museum für Völkerkunde

Central Africa, the vast area surveyed in this exhibition, is geographically and culturally diverse. It extends more than 1,100 miles from the Atlantic Ocean eastward to the Great Lakes, and more than 1,300 miles north to south, and covers the countries of Zaire and adjacent parts of Angola and the People's Republic of Congo. Straddling the equator is a broad expanse of tropical rain forest, home to scattered, sparsely populated communities. North and south of the rain forest are areas of savanna grasslands that saw the development of powerful kingdoms, particularly in the south. Forest and savanna alike are dominated by the great curve of the Zaire River, one of the longest rivers in the world. Its many tributaries—Kasai, Kwango, Kwilu, Lomami, Lualaba, Ubangi, and Uele—have served as magnets for the people of Central Africa who fish and trade along their waterways and farm their fertile valleys.

Most of the people in Central Africa today speak Bantu languages. Their ancestors began a slow drift into this area from their original homeland, probably located in modern Cameroon, in the last centuries before Christ.[1] By the beginning of the second millennium A.D. Bantu-speakers dominated almost all of Africa south of the equator. Because of their dual skills of growing food and working iron, they managed to assimilate the indigenous hunter-gatherer peoples they encountered or to drive them to less desirable areas. Cereal plants and African yams had already been cultivated in the West African savanna and forest and had begun to be grown in Central Africa.

The spread of agriculture was accelerated as early as the beginning of the first millennium A.D., when new crops, bananas and Asian yams, were introduced to Africa from Southeast Asia. In the sixteenth and seventeenth centuries, after the completion of the Bantu expansion, a number of American plants, including maize and manioc, were also added. To cultivate successfully, the Bantu immigrants needed iron tools. By the sixth century B.C. a flourishing ironworking industry existed in northeastern Africa at Meroe, the "Birmingham of Africa." By A.D. 500 iron implements were being used in Central Africa, as shown by archaeological evidence from sites scattered throughout the region (Oliver and Fagan 1978:362).

Agriculture and ironworking, together with other skills such as pottery-making and weaving, provided a more stable and pleasurable living than hunting and gathering. Moreover, they fostered a dramatic increase in the population and consequently led to fundamental social and political changes. Social distinctions became evident as the heads of certain families succeeded in accumulating wealth and power. For example, the eleventh- to fourteenth-century graves excavated at Sanga in southeastern Zaire included some individuals whose high status was reflected in the elaborate copper, iron, ivory, and bead implements and ornaments with which they were buried. These imply the existence of craft specialization, long-distance trade, and hierarchical political structures (de Maret 1977:328). A major conse-

quence of the new social and economic conditions was the development of "sacral kingship," a political institution that would become typical of the southern Central African savanna, where many kingdoms arose between the fourteenth and seventeenth centuries. In this system, royal men inherit the special quality of leadership, which is activated in their blood only when they undergo the sacred rituals of the royal investiture ceremony.

The prestige and power of kings and chiefs is one of the major themes in the art of the Central African savanna. Royal figures, stools with caryatid figures, staffs of office, luxurious woven, embroidered, and appliquéd textiles, and elaborately decorated utilitarian objects, all serve to distinguish the king or chief and to represent his authority among his subjects. Sculptures created to house and manipulate spiritual forces constitute another major component of southern savanna art. These carved wood figures are empowered by a ritual specialist, who adds diverse ingredients—special earths and stones, vegetable materials, parts of birds and other animals, mirrors, metal blades and nails, cloth and fiber bindings—to attract forces and direct them to a desired goal, such as healing an illness, afflicting an enemy, or taking an oath. Masks, often brilliantly painted or made with a variety of luxury materials, are worn at initiation and funeral rituals, which mark life's most important transitions. They constitute the third major aspect of the art of this region.

When the first Portuguese ships exploring the coast of Africa reached the mouth of the Zaire River in 1482, they encountered the already vast and thriving Kongo kingdom. Founded in the last half of the fourteenth century, Kongo was a model of centralized government, with a divine king and a network of provincial governors, advisers, and village chiefs, until its decline in the eighteenth and nineteenth centuries. Its territory extended from the Atlantic eastward to the Kwanza and Kwango rivers, and in the seventeenth century it numbered some 2.5 million inhabitants. Its arts and crafts, notably wood and

ivory carving, ironworking, pottery, and weaving, were highly developed. Its capital of Mbanza Kongo, later known as San Salvador, traded actively with all parts of the empire and also with neighboring areas.

Kongo kings and chiefs expressed their authority through carved ivory and wood staffs and fly whisks, ivory horns, intricately woven raffia cloths, and patterned caps. Kongo sculptures—stone figures placed on tombs and wooden ones kept in ancestor shrines—are also carved with the personal marks of rank and leadership, which include ornamental scarification patterns, filed teeth, and elaborate hairstyles. Other Kongo sculptures, less descriptive in detail, are the "power figures" (minkisi), whose bodies and heads swell with power-laden materials packed in and around them or bristle with the blades and nails that are inserted when calling upon their potent forces. Kongo sculpture is characterized by a full-volumed naturalism, sensual and expressive features, asymmetrical postures, and a freedom of movement that are rare in African art. Also distinctive is the Christian imagery that Kongo artists began to use following the introduction of Catholicism and Christian ritual objects in the late fifteenth century.

East of the Kongo kingdom, along the valleys of the Kwango and Kwilu rivers, live the Yaka, Suku, Mbala, Hungaan, and other peoples, among whom political power is vested in local chiefs. Figure sculptures in this region are intended to provide protection against illness and misfortune and are characterized by the rhythmic angularity of their forms and by the gestures of hands placed on the chin. Masks worn to celebrate boys' circumcision and initiation appear in ensembles depicting a variety of characters and are distinguished by upturned noses and the addition of brightly painted raffia-fiber coiffures and superstructures.

Farther east, in the fringes of forest found between the Sankuru and upper Kasai rivers of central Zaire, lies the Kuba kingdom, whose present dynasty was founded in the early seventeenth century. The Kuba kingdom is organized in an efficient bureaucracy whose officials require splen-

did and sumptuous articles as tangible signs of their wealth and rank. Figurative sculpture is rare among the Kuba, except for a series of royal portraits. Instead, Kuba art consists of utilitarian objects—cups for drinking palm wine, boxes for storing cosmetics and valuables, pipes, spoons—all of which are elaborated beyond mere function by their sophisticated, imaginative, and often playful forms and lavish surface decoration. The intricate incised geometric patterns that cover the surfaces of Kuba objects are borrowed from the motifs embroidered on their luxurious raffia pile cloths. This decorative approach to surfaces extends also to the masks worn at initiations, funerals, and court ceremonies. Kuba masks are copiously ornamented with painted designs, glass beads, cowrie shells, leather, fur, and metal sheets to produce dazzling contrasts of color, pattern, and texture.

The Chokwe are located between the upper Kwilu and Kasai rivers in northeastern Angola and neighboring Zaire. Although they had lived under a system of chieftaincy imposed by the Lunda in the seventeenth century, it was only as a result of changing economic conditions in the mid-nineteenth century that the Chokwe expanded their territory, and their chiefs increased their wealth and influence. Chokwe art includes figures depicting chiefs and royal women, as well as luxury items made for use by such personages. The figures are characterized by powerful, swelling musculature and elegant, refined facial features, dress, and other attributes. Curves predominate in Chokwe figurative sculpture, from the sweeping baroque forms of the chief's headgear depicted on the figures to the precisely rendered pointed oval eyes and surrounding sockets. Richly textured geometric patterns decorate Chokwe staffs of office, chairs and stools, containers, combs, pipes, and other objects that indicate status.

On the eastern edge of the southern savanna of Central Africa live the Luba and other peoples with related art traditions—the Songye, Lulua, Hemba, and others. Early in Central African history, this area, which is favorably endowed with

copper and salt deposits and a system of rivers for both trade and fishing, saw the development of hierarchical societies whose leaders made use of prestige materials and objects to proclaim their status. The Luba empire arose in the seventeenth century and collapsed—like so many other Central African kingdoms—in the late nineteenth century, its population exhausted and its resources depleted by the slave and ivory trades. Luba kings and chiefs employ magnificently carved regalia—caryatid stools, paddlelike staffs, three-pronged bowstands, cups, headrests, ceremonial weapons, and personal ornaments—which are distributed at the installation rituals of chiefs as a means of extending royal power to outlying areas. Luba leadership arts often depict women, images of the king's sisters and daughters given as wives to provincial leaders as a means of solidifying their relationship to the Luba capital. The figures on Luba court objects display such signs of rank as beautifully scarified torsos and intricately coiffed hair. Luba sculpture emphasizes rounded forms and carefully finished surfaces, with smooth, polished areas contrasting with areas of finely textured patterns.

To the north of the Luba, the Songye also have a political system based upon chiefs and titleholders. But unlike their neighbors, Songye culture is distinguished by the formation of large town-states and by the presence of a secret society, *bukishi*, that wields political as well as religious power. While Songye chiefs have such leadership arts as stools with carved human figures, power figures are the predominant form of Songye sculpture. These figures, which vary in size depending on whether they serve an entire community or a single individual, are blocky and angular in form. Their large heads have swelling foreheads and tapering faces. Like their equivalents elsewhere in Central Africa, these neutral, spiritless wooden figures are activated by a ritual specialist, who adds diverse natural and man-made ingredients, charged with magical power, which contribute to the sculpures' distinctive appearance.

In contrast to the savanna kingdoms, the

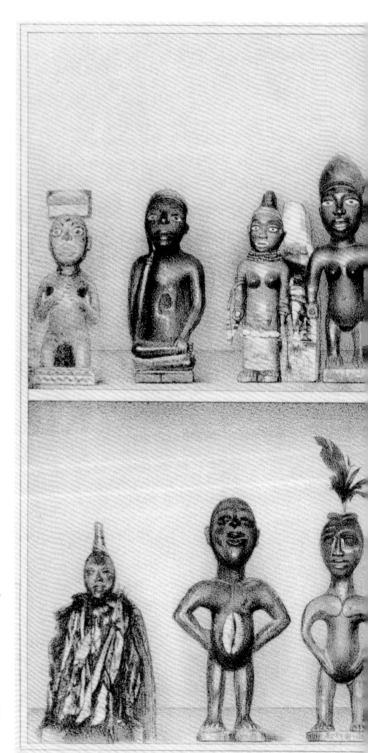

Fig. 2. Kongo power figures in the collection of the Berlin Museum für Völkerkunde, c. 1874 (lithograph from Bastian 1874–75, 2: folding frontisplate). Adolf Bastian, the first director of the Berlin museum and the guiding force behind the formation and display of the fledgling museum's collections, organized an 1873 expedition to the Loango coast, during which many power figures were collected. Some of the pieces in this picture were lost during World War II, but among the survivors is the figure in profile in the top row center (see cat. no. 3). (Photograph courtesy of the Robert Goldwater Library and Photo Studio, The Metropolitan Museum of Art)

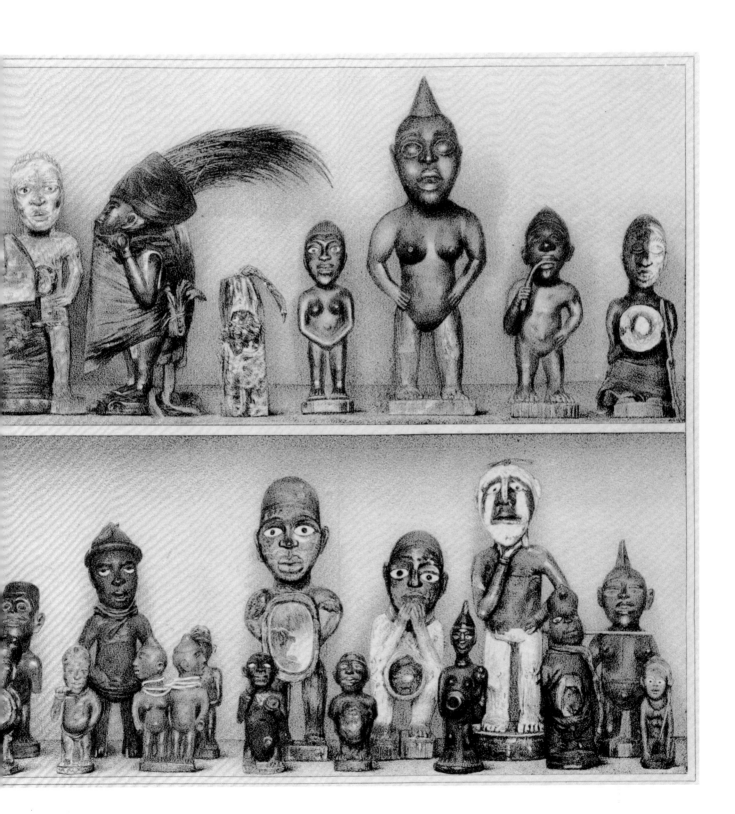

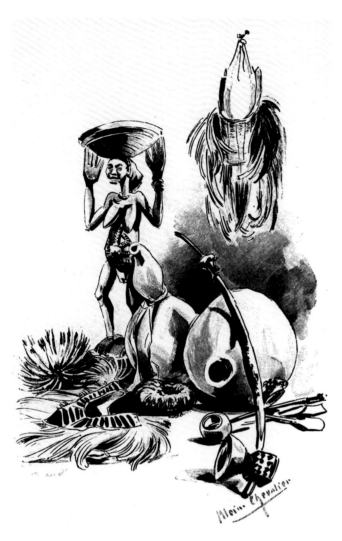

Fig. 3. Artist's rendering of Luba objects collected by Hermann von Wissmann in 1886/87 (engraving from von Wissmann 1890: pl. opp. 136). Von Wissmann, the first European to cross Central Africa from west to east, was also among the first to encounter the Luba peoples of the Kasai River region. He collected many objects for the museum. The stool held aloft by a female figure has many features in common with the Luba stool associated with the Buli Master (cat. no. 50) (Photograph courtesy of Department of Library Services, American Museum of Natural History)

thinly populated forest area of northern and eastern Zaire is home to many small ethnic groups for whom communal voluntary associations, rather than hereditary rulers, are the principal patrons of the arts. The Mangbetu, who formed

a kingdom that lasted throughout most of the nineteenth century, are a notable exception of a forest people who created a court art of great elegance and refinement. Elsewhere in the forest, in the absence of complex and permanent political structures, initiation societies play a crucial role in running village affairs, governing the relationships between people, and guiding an individual's moral development. Among the Lega, for example, the teachings of the Bwami association are made known through a variety of wood and ivory masks, heads, and small figures. Masks and figures throughout this region are characterized by severe geometric abstraction, which usually includes a concave, heart-shaped face, clearly demarked planes and angles often enhanced by the contrast of colors, and a spare sense of surface decoration.

The art of the southern savanna kingdoms of Central Africa is represented much more extensively in this exhibition than that of the forest peoples, reflecting the nature of the holdings of the Berlin Museum für Völkerkunde. Although the museum's collection is vast, because the objects were acquired over more than a century by an assortment of collectors with differing interests and under diverse conditions, it is hardly systematic and comprehensive. The selection included here is similarly far from exhaustive; rather, it focuses on the sculptural, and particularly the figurative, objects in the Berlin museum's collection. Masquerade costumes, textiles, and personal ornaments have not been included here, although these are important art forms in Central Africa and the museum possesses many fine examples. Likewise, utilitarian objects made of pottery, basketry, and metalwork have been omitted, despite the fact that they are often made with as much attention to form, decoration, and technique as the sculptures themselves. Despite its narrow focus, this exhibition provides an illuminating view of the important sculptural traditions of Central Africa and a tantalizing glimpse of the rich collections housed in the Berlin Museum für Völkerkunde.

The Berlin Museum für Völkerkunde, located in West Berlin's Dahlem museum complex, houses some 450,000 objects, representing the cultures of Africa, Oceania, the Americas, Asia, and Europe. Its African collection alone consists of about 40,000 works, including some of the finest examples of Central African art in the world, the masterpieces that make up this exhibition.

Although the museum was not established as a separate entity until 1873, it can trace its beginnings to the sixteenth century when the Elector Joachim II of Brandenburg (reigned 1535–71) began collecting objects for his *Kunstkammer*, or cabinet of curiosities.[2] At his and his successors' requests, German merchants and agents abroad acquired rare and beautiful works wherever they went. While early inventories, beginning with one in 1603, do not list any objects that can be interpreted as African, it is likely that some were in the collection by the beginning of the seventeenth century.[3] Under Grand Elector Friedrich Wilhelm (reigned 1640–88), who used his friendly relations with the Netherlands to increase German overseas trade, the interest in collecting non-European objects grew. German ships were reaching ports along West Africa's Guinea Coast where the Dutch had established trading posts. These early German travelers may have returned to Europe with African artifacts for the royal collection. When these artifacts found their way into the trophy rooms of Europe's nobility, including the Brandenburg electors, they were generally seen as exotic souvenirs from strange, mysterious, and somehow inferior lands. There was certainly no interest in them as serious works of art or as products of significant cultures.

It was not until the nineteenth century that the core of the museum's collection, like all of the major ethnographic collections in Europe, was formed. The year 1830 saw the opening of Germany's first public museum (known as the "Alte Museum," or Old Museum), and the establishment of a separate Ethnographic Department, with

Africa as one of the subsections. Areas of North, South, and East Africa were represented from the beginning. The first West African objects entered the collection in 1844, when the museum purchased 148 pieces made in Dahomey, Old Calabar, Cameroon, Sierra Leone, and the Gold Coast from a German missionary named Halleur. The era of acquisition was under way, and for the next several decades, the history of the museum would run hand in hand with the history of African exploration.

Until the nineteenth century, when Germany emerged as a world power after centuries of political disunity, it had not participated in any major way in the Age of Discovery. The exploration of Africa, however, would include the active participation of German scientists, merchants, missionaries, and other explorers. Europeans had been familiar with the African coastline since the fifteenth century, when the first sailing ships plied its waters seeking new routes to the East. They had seen no need to venture far from the coast, however, where trading posts were established for the acquisition of gold, ivory, spices, and slaves. Consequently, much of the continent's interior remained unknown to outsiders until the mid-nineteenth century. At that time new incentives were found to send expeditions into Africa, including the vast unexplored areas of Zaire and Angola. The search for raw materials essential to the Industrial Revolution, the thirst for knowledge of the geography, flora, and fauna of Africa, the desire by missionaries to bring Christianity to the African peoples, all provided ample motivation, made all the more urgent as European colonization of Africa got under way late in the century.

Some of the first German explorers to venture into Central Africa did so as part of English expeditions.[4] In 1849, the English African Association sponsored an expedition under the leadership of James Richardson, an avid abolitionist, to the southern reaches of the Sahara. The British invited Heinrich Barth (1821–65), who was

Fig. 4. Mangbetu water bottles (engraving from Schweinfurth 1873, 2:116). Georg Schweinfurth, an enlightened collector for the Berlin museum, had a keen appreciation, unusual for the time, of the objects he collected during his expeditions in the late 1860s and 1870s. He admired Mangbetu pottery, particularly vessels for holding water, writing that "upon the water-bottles . . . the greatest care is bestowed, some of which may fairly be said to rival in symmetry the far-famed examples of Egyptian art, and to betray a considerable faculty of plastic genius" (ibid.). (Photograph courtesy of the Robert Goldwater Library and Photo Studio, The Metropolitan Museum of Art)

fluent in several languages including Arabic, to participate, along with two other Germans, Adolf Overweg and Eduard Vogel. Although the official aim of the expedition was to scrutinize the slave trade that persisted in the southern Sahara region, Barth viewed it as a scientific expedition. Over the next six years, alone and with his compatriots, he traveled from Tripoli south to Lake Chad and explored areas that are now parts of Cameroon, Chad, Mali, Nigeria, and Niger. Barth's experiences and observations made him for a time the foremost authority on the region (Barth 1857–58).

In the east, two German missionaries, Ludwig Krapf (1810–81) and Johannes Rebmann

(1820–76), had penetrated the interior from Mombasa to mounts Kilimanjaro and Kenya. Their efforts were continued by Englishmen Richard Burton, John Hanning Speke, and James Grant, who succeeded in discovering the source of the Nile River in 1860. It would be German explorers, however, who would explore most of the regions west of the Upper Nile into Central Africa. In 1868, Georg Schweinfurth (1836–1925), who had already spent two years collecting botanical specimens in Africa, was sponsored by the Humboldt Institution of Natural Philosophy and Travels, under the auspices of the Royal Academy of Science of Berlin, to mount a botanical expedition to the equatorial regions west of the Nile. For more than three years he traveled among the peoples who lived along the Nile's southwestern tributaries (Schweinfurth 1873). He was the first European to cross over into the watershed of the Zaire River, reaching as far as the Uele River. There he encountered the Mangbetu and Azande peoples, among whom he acquired objects for the museum in Berlin.

Schweinfurth encouraged his countryman Wilhelm Junker (1840–92) to continue the exploration of Central Africa. Between 1876 and 1888, Junker made two zoological expeditions, also concentrating in the watershed regions of the Nile and Zaire rivers (Junker 1890–92). Like Schweinfurth, he also collected objects in the Uele River area, some of which are now in the museum in Berlin. Another compatriot and friend of Schweinfurth was Eduard Schnitzer (1840–92; see cat. no. 51), a physician whose love for North Africa and the Sudan had compelled him to change his name to Emin ("the faithful one"); he was known as Emin-Bey, Emin-Effendi, Mohammed Emin, and Emin Pasha (Schweinfurth et al. 1889). This last title was bestowed on him by the British commander, General Charles Gordon, who made Emin governor of Egypt's Equatorial Province. German explorers penetrated other areas of Africa as well: Karl Mauch (1837–75) and Emil Holub were active in South Africa; Gerhard Rohlfs (1831–96) in Abyssinia; Gustav Nachtigal

(1834–85; see cat. no. 30) in the Eastern Sudan;
J. M. Hildebrandt in East Africa and Madagascar;
Oskar Lenz (1848–1925; see cat. no. 18) in the
Western Sudan; and several others.

During their travels, these explorers accumulated all manner of ethnographic artifacts along with scientific data. The collection in Berlin's Alte Museum continued to grow; it was large enough to assure the inclusion of an independent Ethnographic Department when the "Neue Museum" opened in 1856. This was an exciting era for the young branch of the museum, culminating in the 1873 foundation of the Museum für Völkerkunde as a separate institution, with a new building that opened its doors to the public in 1886.

The impetus for founding a new museum was provided largely by one man, Adolf Bastian (1826–1905), who had been appointed administrator of the Ethnographic Department in 1868 and who directed the museum from 1876 until his death. A physician by training, Bastian's interest in psychology had led him to ethnology. He spent several years as a ship's doctor in Asia and later would travel not only to Africa but around the world. Most of his life was devoted to studying non-European cultures. Not only did Bastian command vast first-hand experience, but he was also a formidable theorist. For example, he never fully accepted the Darwinian concept of cultural evolution current at the time.

The evolutionists saw the development of humanity from the earliest beginnings up to the seemingly limitless heights of European civilization as a continuous upward climb and held the cultures of Asia, Africa, and Oceania to be examples of inferior evolutionary "levels." Such a view of culture was ethnocentric in the extreme, denying non-Western peoples the ability to create anything of value. In contrast Bastian had a high regard for cultural artifacts. Recognizing the destructive influence of Europeans on other cultures, he begged researchers to document indigenous cultures with representative ethnological collections before such cultures lost their identity.

In 1877 Bastian organized the Berlin An-

Fig. 5. Carved wood stool (engraving from Schweinfurth 1873, 2:114). This type of stool, with its little triangular opening serving as a handle in the seat, was used by Mangbetu women. Its pedestal base is similar to that on a variety of other objects, as Schweinfurth observed, "even the little cylindrical boxes covered with bark for storing away their knick knacks...[are] finished off in this manner" (ibid.; see cat. no. 58). (Photograph courtesy of the Robert Goldwater Library and Photo Studio, The Metropolitan Museum of Art)

thropological Society and founded, with Robert Hartmann, the journal *Zeitschrift für Ethnologie*, which is still published today. The climate was changing from one of pure exploration and acquisition, to one that included study and analysis. In 1873, the year of the museum's founding, Bastian had established the German Society for the Exploration of Equatorial Africa, which in 1878 became known as the African Society in Germany. With the authorization of the society, Bastian organized an expedition to the Loango coast, north of the mouth of the Zaire River, which he had visited earlier, in 1857 (Bastian 1859). The goal of the expedition was to study the people of the region. Bastian himself spent the months of

June to October there (see cat. no. 16), although the expedition was actually led by Paul Güssfeldt (1840–1920; see cat. nos. 3, 9; Bastian 1874–75; Güssfeldt 1875a and b; idem 1876).

In addition to the Loango Expedition, many other expeditions to Central Africa took place in the 1870s and 1880s, sponsored by the African Society and the Berlin Geographical Society, of which Bastian was elected president in 1876. One of these was the 1874–76 expedition to the Kasai River region led by ornithologist Alexander von Homeyer (1834–1903), accompanied by Paul Pogge (1838–84) and Anton Erwin Lux (1847–1908; Pogge 1880). Pogge alone attained the expedition's goal, which was the residence of the Mwata Yamvo, the Lunda ruler, but both he and von Homeyer brought back important Chokwe objects for the Berlin museum (see cat nos. 34, 36). In 1878–79 Otto Schütt also traveled to the Kasai region and penetrated as far as the Chicapa River, a tributary of the Kasai, where he collected the Chibinda Ilunga figure (cat. no. 29). Pogge returned to Zaire in 1880, accompanied by army officer Hermann von Wissmann (1852–1905). In 1883 the two reached Yanouge on the Lualaba River where they parted company. Pogge returned to the west coast, where he died a short time later, though he did manage to acquire additional objects for the museum. Von Wissmann proceeded eastward until he reached Africa's east coast, becoming the first European to cross the Zaire region, coast to coast, from west to east (von

Fig. 6. Drawing of a carved elephant tusk (from Bastian 1874–75, 1: folding endplate). Adolf Bastian's 1873 expedition collected the carved elephant tusk (cat. no. 16) from which this drawing was made. These tusks were made by Kongo artists along the Atlantic coast near Loango primarily for European collectors. They convey a tantalizing hint of African attitudes toward Europeans. A lively parade of subjects—from copulating pigs to baboons, turtles, crabs, and people, all engaged in various activities—culminates in a couple in European dress and a child at the pinnacle. (Photograph courtesy of the Robert Goldwater Library and Photo Studio, The Metropolitan Museum of Art)

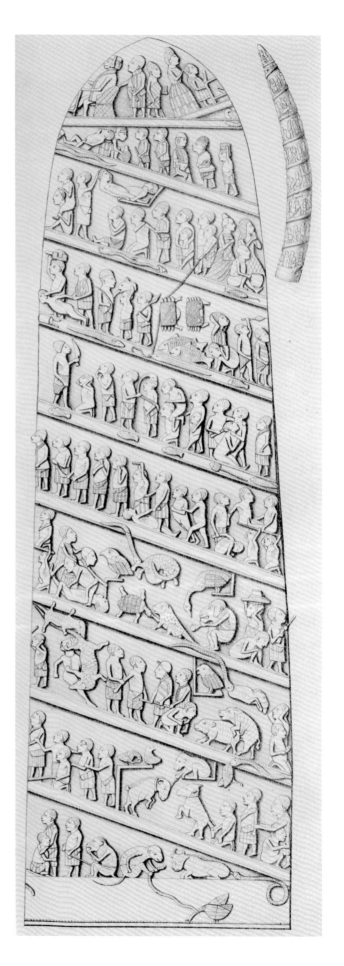

Wissmann 1902; see cat. nos. 41, 43, 47). Until then, the only other European to cross Central Africa from coast to coast had been Englishman Henry Morton Stanley who had traveled in the other direction on a 999-day expedition (1874–77). Von Wissmann made two other expeditions to the Kasai region. In 1884, with three fellow officers, Kurt von François, Ludwig Wolf, and Hans Mueller (see cat. nos. 38, 42, 53), he explored the area between the Kasai and Lulua rivers (von Wissmann et al. 1891), and in 1886/87, he once more visited Yanouge and crossed to the east coast (von Wissmann 1890b).

During the 1880s, the European scramble for colonies in Africa was intense. Within ten years the map was carved up primarily between England, France, and Portugal. The Zaire region, which Stanley had hoped to gain for England, went instead to Belgium as the Congo Free State through the maneuverings of King Leopold II. Leopold personally funded several expeditions into the region, including von Wissmann's second one.

The Germans, who under Bismarck had hosted the 1884 Congress of Berlin that had decided much of the partitioning of Africa, had been late in entering the rush for colonies. Even so, after 1885, Germany acquired Togo, Cameroon, and South-West Africa, on the west coast, and German East Africa, on the east. With the acquisition of colonies, the flow of material into the Berlin museum increased substantially. There had been about 3,500 objects in the collection in 1880, and by 1886, when the new museum opened its doors at Königrätzer Strasse 120 (later changed to Stresemannstrasse 110, now part of East Berlin), there were about 10,000, an increase of 200 percent. Much of the material came from cultures in the new German colonies, but the museum did acquire a number of remarkable collections from Central Africa as well. These came mainly from merchants active in the region at the turn of the century.

Robert Visser, for example, who originated from Büderich near Düsseldorf, lived on the Loango coast from 1882 to 1894 where he was an agent of a Dutch trading and plantation enterprise. He collected a great number of artifacts, and when he returned to Germany, he donated much of his collection to German museums in Stuttgart and Leipzig, among others (Zwernemann 1961:15). Between 1895 and 1905, the Berlin museum acquired about six hundred of his pieces, including several hundred power objects (see cat. nos. 1, 2, 4, 12). Felix von Luschan (1854–1924), who had worked at the Museum für Völkerkunde since 1885 and became curator of its Africa-Oceania Department in 1905, placed a value of 15,000 to 20,000 marks on this acquisition (close to $100,000 in today's terms) and arranged for Visser to be awarded a medal in recognition of his service to the museum.[5]

Von Luschan made many valuable contributions to the history of the museum's Africa Department, and to the appreciation of African art in general. He was one of the first champions of the art of Benin, which was exhibited in London in 1897 after the British Punitive Expedition in Nigeria. It was von Luschan who first dared to compare the bronzes of Benin to the best art of Europe. In 1901, in an appreciation altogether remarkable for its time, he wrote: "These works from Benin are equal to the very finest examples of European casting technique. Benvenuto Cellini could not have cast them better, nor could anyone else before or after him, even up to the present day. Technically, these bronzes represent the very highest possible achievement" (von Luschan 1901:10).

In 1904 the Berlin museum acquired part of another important Zaire collection, that of Leo Frobenius (1873–1938), who later gained renown for his studies of African cultural history. Between 1893 and 1904 Frobenius had amassed a collection of 1,117 objects from Central Africa, buying many of them from the Hamburg dealer J. F. G. Umlauff. He offered the entire collection to the Berlin Museum for 34,000 marks (more than $160,000 today), which he needed to finance his own expedition to Central Africa, on which he

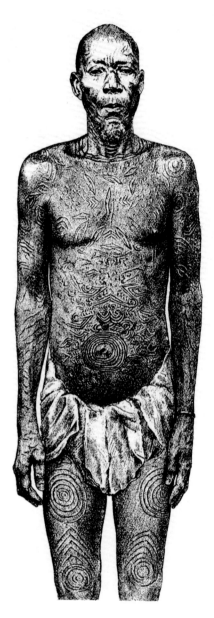

Fig. 7. A Lulua man with scarification patterns similar to those on the carved warrior figure in the exhibition (cat. no. 38; engraving from von Wissmann et al. 1888: pl. opp. 164). During explorations into the interior, Hermann von Wissmann and his compatriots Kurt von François, Ludwig Wolf, and Hans Mueller traveled among the Lulua people. They found that even at that time, the practice of scarification was diminishing among the Lulua and was preserved primarily on sculpture. (Photograph courtesy of Department of Library Services, American Museum of Natural History)

collected hundreds of objects now in the Hamburg Museum für Völkerkunde (Frobenius 1907, 1985–88; Zwernemann 1987). Bernhard Ankermann (1859–1943), then a research assistant at the Berlin museum, urged von Luschan to accept Frobenius's offer, writing, "At least we would then own a collection of masterpieces of African woodcarving like no other museum's . . . for it is no longer possible to put together a choice selection like this. . . . If only it weren't so expensive!"[6] Ultimately von Luschan did purchase some 728 items from Frobenius for 10,000 marks.[7]

As the pieces in this exhibition reveal (see cat. nos. 23, 25–27, 39, 40, 44, 48, 58, 60), the collection was of the highest quality, attesting to Frobenius's professional competence and unerring eye for quality. Like von Luschan, Frobenius had come to appreciate African works as art, an almost unheard of perspective at the time, writing as early as 1898 about the "treasures" in ethnological collections and speaking perceptively of their "greatness" (Frobenius 1898a:ix). This early conviction about the importance of African art was strengthened by Frobenius's many expeditions to Africa. In 1931 when Europe was just beginning to appreciate African art, we find him marveling at Africa's "ravishing splendors" and describing the artistic sensibility of the peoples of Zaire with utmost enthusiasm: "Every cup, every pipe, every spoon a work of art, altogether deserving of comparison with products of the Romanesque style in Europe" (Frobenius 1931: 86, 87).[8]

Von Luschan, like his predecessor Bastian, had become vexed by the problem of poor documentation of the objects entering the museum's collection. He eventually wrote a pamphlet entitled *Instructions for Ethnological Observations and Collections in Africa and Oceania* (von Luschan 1904). It is not surprising that attribution and documentation were so weak, since the earliest objects in the collection had not been gathered in the field systematically. Their acquisition had not been a primary aim of expeditions led by natural scientists, doctors, and military men who were

charged with studying the geography, geology, meteorology, zoology, or botany of a region. Matters of physical anthropology, linguistics, ethnology, and archaeology were purely secondary to the explorers, and artifacts were collected haphazardly. Their selection might be based on personal taste or simply on the serendipity of travel. The minor importance placed on these objects is made clear in a typical field report, submitted by Emin Pasha (under the name of Dr. Emin-Bey) after an expedition to the western shore of Lake Albert in 1879:

> I have just returned from a journey to the west shore of Lake Albert, which had not been explored heretofore. In addition to making careful corrections in the matter of place names, which had been most inaccurately recorded before, I kept geographical notes regarding regions and peoples, regarding customs, morals, and ways of life, compiled a roughly 400-word vocabulary of the Lur dialect, which is a previously unknown example from the family of Shilluk languages and states formed by the great Shilluk migration in the past. Further, I made collections of shells, of mud samples from the lake, of birds, a number of which are new for northeast Africa, and of ethnological objects. I also made notes on the geographic distribution of numerous animal and plant species, as well as observations, based on stone samples, of the hot sulphur springs on the lake shore (Schnitzer/Emin-Bey 1880:263).

By the twentieth century, the collection had outgrown its exhibition space, and in 1905 much of it was transferred to a newly built warehouse in the Dahlem area, where the museum is now located. New exhibition space became a priority, and plans were made to build a museum complex near the warehouse, with each building housing a separate department. Construction got under way in 1914, but because of World War I, the first building was not completed until 1921. Although originally intended for the art of Asia, it was used to house the Africa study collection instead. By this time, von Luschan had retired (1911) and

after internal reorganization, Ankermann succeeded him first as curator of the Africa-Oceania collection, then as Director of the African collection (1916–24).

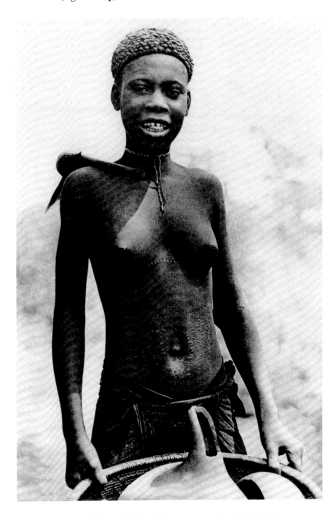

Fig. 8. A Chokwe girl on her way to the fields (photograph from Baumann 1935: pl. 19). In 1930, Hermann Baumann mounted what might be considered the last of the Berlin museum's African expeditions of acquisition. He worked in Angola among the Lunda and related Chokwe peoples. This Chokwe girl embodies their ideals of beauty in her hairstyle, filed teeth, tongue gesture, necklace, and body-scarification patterns. The same attributes are captured in the female figure in the exhibition (cat. no. 31), collected almost fifty years before this photograph was taken. (Photograph courtesy of Department of Library Services, American Museum of Natural History)

Two other important collections from Central Africa entered the museum around this time, and each was formed by a museum staff member engaged in anthropological research in Angola. Alfred Schachtzabel had joined the museum in 1911 and was working in the field in the Benguela Highlands of Angola in 1914 at the outbreak of World War I (Schachtzabel 1923). He was able to leave the country, but it took him five years to reach Berlin. Only a small part of his collection, some 336 objects, remained intact and eventually found its way to the museum. The rest was confiscated in Angola and sold at auction. Upon Ankermann's retirement in 1924, Schachtzabel was named curator of the Africa Department, a position he held until 1945.

The other Angola collection consisted of 1,375 objects assembled by the Africa scholar Hermann Baumann (1902–72; see cat. nos. 32, 33), who worked for the museum from 1921 to 1934 and was curator of the newly established Eurasian Department from 1934 to 1939. His collection was the result of a highly successful 1930 expedition into northeast Angola, the only African expedition the museum was to mount between the wars (Baumann 1935).

During this period, ethnologists were trying to put behind them the notion of evolutionism and other extreme, historically oriented cultural theories. They began to concentrate instead on the social and religious aspects of culture. The new "social anthropologists," whose contribution to ethnological research in Africa was immense, often collected artifacts for the museum but classified them under the rubric "material culture" rather than art. Ethnologists did not consider it their job to deal with art as such. It would still take decades before scholars recognized that by ignoring the artistic qualities of these objects they were robbing them of their essential nature and in so doing failed to appreciate fully other facets of culture as well.

The years from the end of World War I to the end of World War II were especially trying for the museum. Although it managed to stay open to the public for most of the period, it had difficulty with funding, acquisition, and space. During World War II, it removed many of its most precious pieces from exhibition to flak shelters in the Zoological Garden in Berlin. In 1944, other pieces that had remained on display were shipped to Castle Schräbsdorf in Silesia. A third group of objects was sent to potash mines at Kaiseroda and Grasleben.

By war's end, the damage to the collection had been devastating. Flak shelters and potash mines had been bombarded and demolished or had fallen into Russian hands; the pieces in Silesia (part of modern-day Poland) had disappeared. Only objects that had been sent westward, falling into American and British hands, were eventually returned. Of the 66,953 objects in the Africa collection at the beginning of the war, only about half remained. Also destroyed were irreplaceable study materials: the card catalogue to the collection, the department library, the manuscript collection, photo archives, and film collection.

The postwar years have provided the museum with the greatest challenge of its history. Much of the task of rebuilding the Africa Department fell to Kurt Krieger, who served as curator from 1945 to 1985 and functioned simultaneously as the director of the entire museum beginning in 1962. The objects surviving the war had to be inventoried and their catalogue records often reconstructed. The results of this effort are evident in Krieger's three-volume catalogue of the collection's sculptures and the single volume, prepared with Gerdt Kutscher, devoted to its masks (Krieger and Kutscher 1960; Krieger 1965–69). These publications concentrate on works from "West Africa," a term that in the German anthropological literature includes what English writers most often call West and Central Africa.

The work of inventorying the collection made its losses all the more evident, so that since the war there has been a concerted effort to fill the gaps. Most of the losses had been in the "West African" collection, and this area, which includes Zaire, Angola, and the People's Republic of

Congo, has been the focus of new acquisitions. The process is still under way, and some of the most recently acquired objects can be seen in the present exhibition (see cat nos. 13, 15, 19, 21, 22, 28, 55, 57, 61).

The Museum für Völkerkunde now occupies, along with six other museums, an International-style building on the old Dahlem site. In 1973, a century after the museum's founding, the permanent exhibition of the Africa Department was installed. Today, as then, the collection is arranged geographically, beginning with North Africa, the Sahara, the Western Sudan, and the Guinea Coast, continuing through the Ife and Benin material from Nigeria, and ending with sections devoted to southwestern Cameroon and the Cameroon Grasslands. Objects have been chosen to illuminate various aspects of African culture, such as its economy, religion, or artistic techniques. The explicit goal is "to show the cultural heritage of the people of each region—insofar as it can be represented in a museum setting—as a complete whole, not torn into individual, unrelated parts, for example, through the one-sided separation of art" (Krieger 1973:135).

German ethnologists have been preoccupied since the 1960s with the "museum question," with the relevance of museums in a modern ethnological context. Significant numbers of them are openly scornful of art or art exhibitions. "The ethnographic museum is not a museum of primitive art, however artistically constructed certain of its ethnographic artifacts may seem. Of course it is up to the visitor to approach them aesthetically as he chooses" (Kelm and Münzel 1974:4). To the European, the social and economic problems of the Third World tend to overshadow its artistic production. Any accurate evaluation of non-European cultures would necessarily concentrate not on their art, but rather on "the day-to-day life that millions of people have lived for hundreds of years, with all of its tragic and unpleasant aspects" (Hoffmann 1979:116).

At present, space in the Museum für Völkerkunde does not permit the exhibition of objects from Central, South, or East Africa. Partly because of this, Central Africa was chosen as the focus when the opportunity arose in 1987 for a major exhibition of the Africa Department's collection. This exhibition *Zaïre: Meisterwerke afrikanischer Kunst*, which was on view in Berlin from June 19 to August 16, 1987, included close to 200 objects (Koloss 1987), the highlights of which constitute the Metropolitan Museum's exhibition and this catalogue.

When it was shown in Berlin, the exhibition focused on the artistic achievements of the peoples of Central Africa. This reflects the progress that has been made in recent years in studies of African art and society. It also shows the changes in outlook that have occurred in the Berlin Museum für Völkerkunde. Objects that were once considered merely curiosities in the cabinets of the aristocracy, or evidence of the "inferiority" of peoples different from those collecting, are now beginning to receive the recognition they deserve.

1. For an overview of the Bantu expansion in Africa south of the equator, see Oliver and Fagan 1978 and Birmingham 1983.

2. I am especially indebted to Dr. Kurt Krieger for much valuable information. His overview of the history of the Africa Department of the Berlin Museum für Völkerkunde was especially helpful in preparing this essay (Krieger 1973). For an English summary, see Rumpf and Tunis 1984.

3. For the history of the Berlin *Kunstkammer*, see Theuerkauff 1985.

4. In this essay, much of the information about the early explorers is based on Hassert 1941, Henze 1978, and Hibbert 1982.

5. Letter to the museum's General Administration, July 14, 1905 (E 1355/05).

6. Letter to von Luschan, March 7, 1904 (E 997/04).

7. This price seems low by today's standards, but may have been appropriate at the time. Zwernemann, however, relates that the Hamburg Museum für Völkerkunde rejected the average price of 10 marks per item to be paid for the Frobenius collections as too high (1987:113).

8. The objects for which Frobenius is perhaps best known are the Ife terracotta heads he acquired on his trip to Nigeria in 1910–12. These can now be found in the Berlin Museum für Völkerkunde.

Catalogue of
the Exhibition

Contributors

David Binkley	DB
Arthur Bourgeois	AB
Kathy Curnow	KC
Kate Ezra	KE
Dunja Hersak	DH
Hans-Joachim Koloss	HJK
Wyatt MacGaffey	WM
Polly Nooter	PN
Enid Schildkrout	ES

1. POWER FIGURE: STANDING MAN
 Congo, Loango; Kongo, 19th century
 Wood, metal, feathers, nuts, fiber, cord,
 pigment, cloth, organic materials,
 H. 34⅝ in. (88 cm.)
 Gift of Robert Visser, 1904 III C 18914

The Kongo recognize two kinds of power objects
(*minkisi*; singular, *nkisi*), violent and benevolent
(MacGaffey 1986, 1988). This is a type of violent *nkisi*
called *nkondi* (plural, *minkondi*). At the turn of the cen-
tury, each Kongo region had several local varieties of
minkondi; the identity of this Loango type is not known.
Minkondi were activated by driving nails, blades, and
other pieces of iron into them to provoke them into
inflicting similar injuries on those guilty of theft or
other crimes. Anyone afflicted by an ailment attribut-
able to one of the *minkondi*—headaches, nightmares,
chest pains, and other discomforts of the upper body
—could be cured by a priest (*nganga*) of *minkondi*. Power
objects were originally painted white, black, and red.
White is associated with clairvoyance and the land of
the dead; black, with violence; red, with the transmis-
sion and mediation of powers (Jacobson-Widding 1979).
In combination and context, the significance of colors
can be both subtle and complex. WM

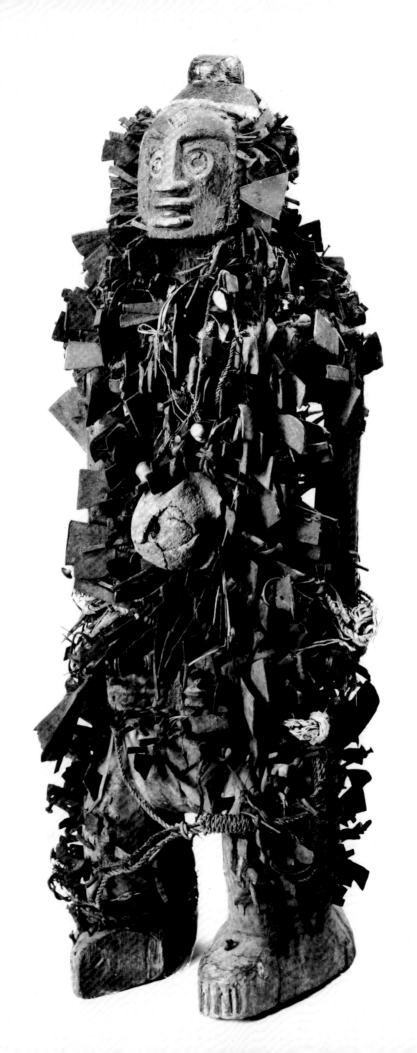

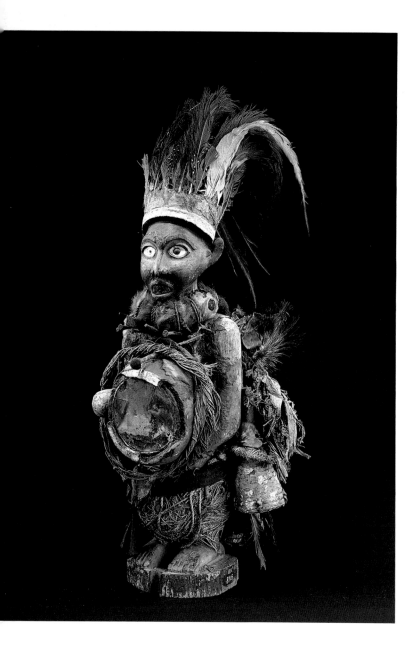

2. POWER FIGURE: STANDING MAN
 Congo; Vili, 19th century
 Wood, glass, porcelain, metal bells, nails,
 hide, fur, feathers, cloth, fiber, basketry,
 organic materials, H. 17¾ in. (45 cm.)
 Gift of Robert Visser, 1898 III C 8105

This violent or retributive *nkisi* may also be a *nkondi* type, although not all power objects with nails in them were regarded as *minkondi*. Violent *minkisi* were either "of the above" or "of the below." The feathered headdress of this one makes it "of the above," associated with storms and birds of prey. All *minkisi* are empowered by "medicines" (*bilongo*) hung about them or in the form of a resin pack actually attached to the head, belly, or elsewhere. The medicines, usually vegetable materials, indicate a *nkisi*'s particular powers, thus the injuries or diseases it was believed to be capable of inflicting on wrongdoers. An ingredient would be selected as a medicine because it suggested by its physical properties and associations, or by a pun on its name, a quality to be attributed to the *nkisi*. For example, charcoal (*kalazima*) helped the *nkisi* to "be alert" (*kala zima*), a parrot feather enabled it to "speak to reveal secrets," or a stone showed that it dealt with tumors. Clients also added small packets containing hair, fingernail clippings, shreds of clothing, or other relics to remind the retributive *nkisi* of the particular problem and the person to attack. WM

3. POWER FIGURE: STANDING MAN
 Congo, Loango; Vili, 19th century
 Wood, glass, broadcloth, velvet, feathers,
 organic materials, H. 14½ in. (37 cm.)
 Collected by the Loango Expedition, 1872
 III C 531

Violent *minkisi* such as this one were often anointed with the blood of chickens sacrificed as a gift to the *nkisi* and as an example of the kind of violence expected of it. The feathered headdress associates the *nkisi* with forces in the sky. The unusual turtle base may signify that this *nkisi*, so as not to be seen by evil spirits, can hide its head like the turtle. The imported cloths take the place of raffia that might once have been used to conceal the medicine pack on the torso. A mirror on such a pack was used to frighten witches by its glitter and also, in some *minkisi*, as a divinatory device to detect them. The object in the mouth of this *nkisi* is probably a piece of *munkwiza* creeper, whose juice was used to test suspected witches, suggesting that this *nkisi* may have had judicial functions. WM

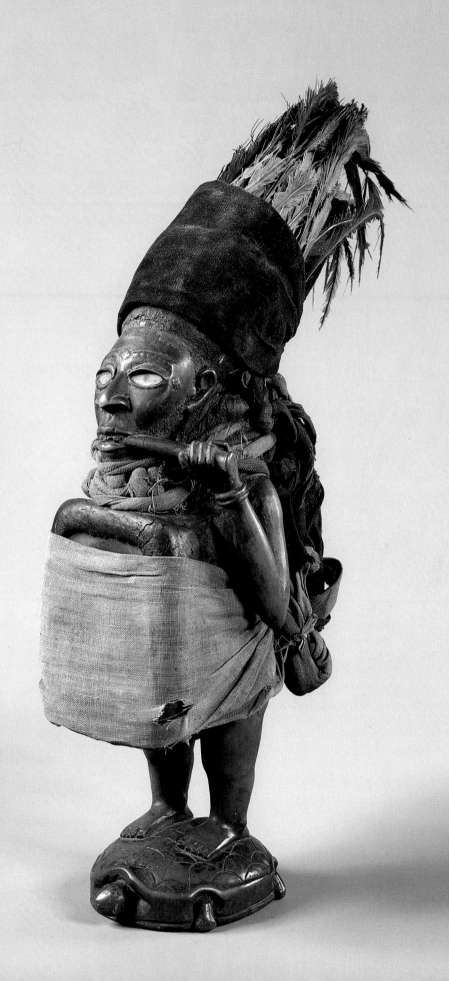

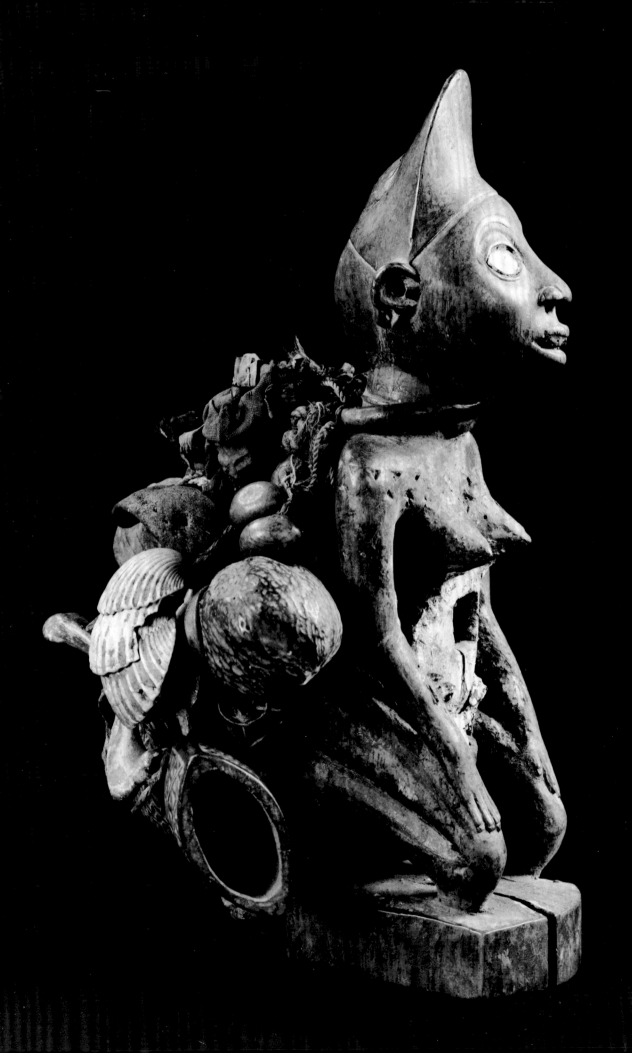

4. POWER FIGURE: KNEELING WOMAN
Congo, Loango; Kongo, 19th century
Wood, brass, glass, cloth, leather, fruits,
seeds, shells, fur, fiber, horn, clay, organic
materials, H. 9⅞ in. (23.5 cm)
Gift of Robert Visser, 1901 III C 13621

This *nkisi*, unlike cat. nos. 1 to 3, has a benevolent func-
tion, perhaps that of enabling a woman to have a child.
The kneeling posture indicates supplication. The shells
on its back associate it with the water, from which its
empowering spirit comes. The small cloth packets and
the antelope horn contain either medicines or tokens
of a particular individual who has sought help. The
belly once held a medicine pack as well. The multi-
plicity of significant odds and ends helped to create
the impression, in the minds of those who participated
in the rituals, that a *nkisi* had remarkable powers. WM

5. STANDING FEMALE FIGURE
Congo; Kongo, 19th century
Wood, glass, H. 13¾ in. (35 cm.)
Purchased from J. F. G. Umlauff, 1905
III C 20277

The Berlin museum purchased this figure from
J. F. G. Umlauff, whose Hamburg shop specialized in
ethnographic objects. Its scant collection informa-
tion—"probably Loango"—illustrates the imprecise
way in which early collections were documented. While
Umlauff's agents may have acquired this figure some-
where on the Loango coast (although even that is not
certain), it probably originated in the basins of the
middle Niari and middle Loudima rivers.

The figure's style also indicates the complex relation-
ships among ethnic groups and art traditions in this
region. The glass-inlaid eyes, filed teeth, hatlike coif-
fure, and cord above the breasts are features of many
Kongo sculptures. The luxurious scarification that cov-
ers torso and shoulders, the thick neck, actively bent
knees and elbows, and the gourds clasped in each hand
are found on sculptures attributed specifically to the
Bembe and Bwende groups of the Kongo. However,
the latter features, as well as the curved lips and softly
rounded face, are also found on some figures attrib-
uted to the Lumbo and Punu peoples who live farther
north in the People's Republic of Congo and Gabon
(e.g., Sieber and Walker 1987: no. 39). The movement
of ethnic groups, artists, and objects in Lower Zaire,
as well as the cavalier methods of early collectors
often conspire to frustrate present-day African art
historians. HJK/KE

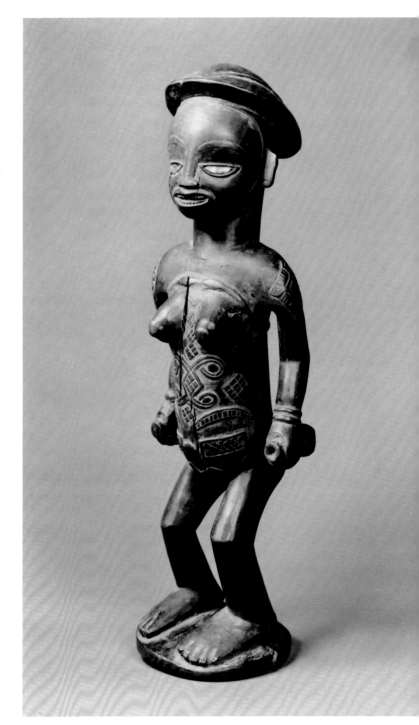

6. KNEELING WOMAN AND CHILD
Congo and Zaire; Yombe, 19th century
Wood, H. 11¾ in. (30 cm.)
Gift of Wilhelm Joest, 1896 III C 6286

Figures representing a woman with a child are common in the art of the Kongo peoples of Lower Zaire, especially among the Yombe. The mother is often depicted with the marks of high social status and consciously acquired beauty: a high miter-shaped hairstyle, filed teeth, a necklace of glass or coral beads, a cord tied above the breasts, and bracelets and armbands.

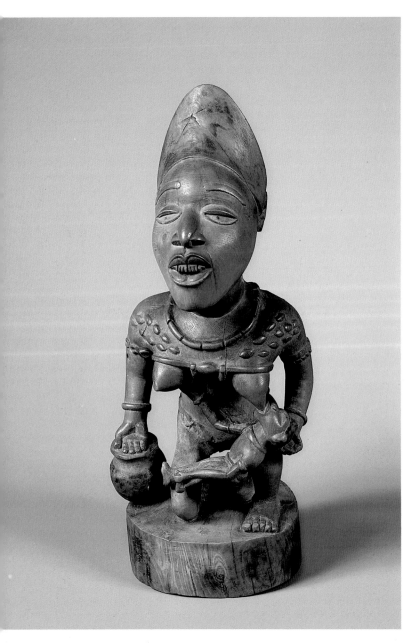

Although such figures are usually depicted seated with crossed legs, this one crouches with one knee on the ground, the other raised. The baby, who nurses eagerly at one breast and reaches toward the other, lies awkwardly across the mother's lap, its head cupped in her hand. The mother rests her other hand, palm upward, on a pottery jar at her side.

A Yombe wooden mother-and-child figure in the Musée Royal de l'Afrique Centrale in Tervuren is reported by its collector, Léo Bittremieux, to have been owned by a powerful male diviner for whom it represented the source of his own divinatory and generative powers. It was called *phemba*, a word that Bittremieux thought to be derived from *kivemba*, meaning to broadcast or eject, as in the seeds of potential children which accumulate in either a man or a woman. Thus, rather than representing a particular woman and child, or even a concept as specific as motherhood, the Yombe image of a nurturing woman may express the more general idea of fertility and creativity as it applies to all people, male as well as female (Maesen 1960: pl. 1; van Geluwe 1978: 147–50).

The figure was given to the Berlin museum by Wilhelm Joest (1852–98), an anthropology professor whose vast collection of objects from around the world formed the basis for the Rautenstrauch-Joest Museum in Cologne. HJK/KE

7. MASK
Congo; Vili, 19th century
Wood, paint, fur, lizard skin, cord,
H. 14½ in. (37 cm.)
Gift of Wilhelm Joest, 1887 III C 3906

Masks of this type (*ngobodi* or *ditombula*), which belonged to diviners and healers, display the naturalistic features typical of western Kongo figurative sculpture. Masks from the northwestern Kongo kingdom, as well as those from the coastal region, are often painted more than one color: white and black, white and red, or as in this example, white, black, and red, a triadic color scheme identifying the contradictory and mysterious nature of diviners. White stands here for the good life, female fertility, health, and social harmony. It also relates to female ancestral spirits (*simbi*). Black designates misfortune and disorder. Red means magical potency, authority, marginality, and masculinity (Maesen 1987). HJK

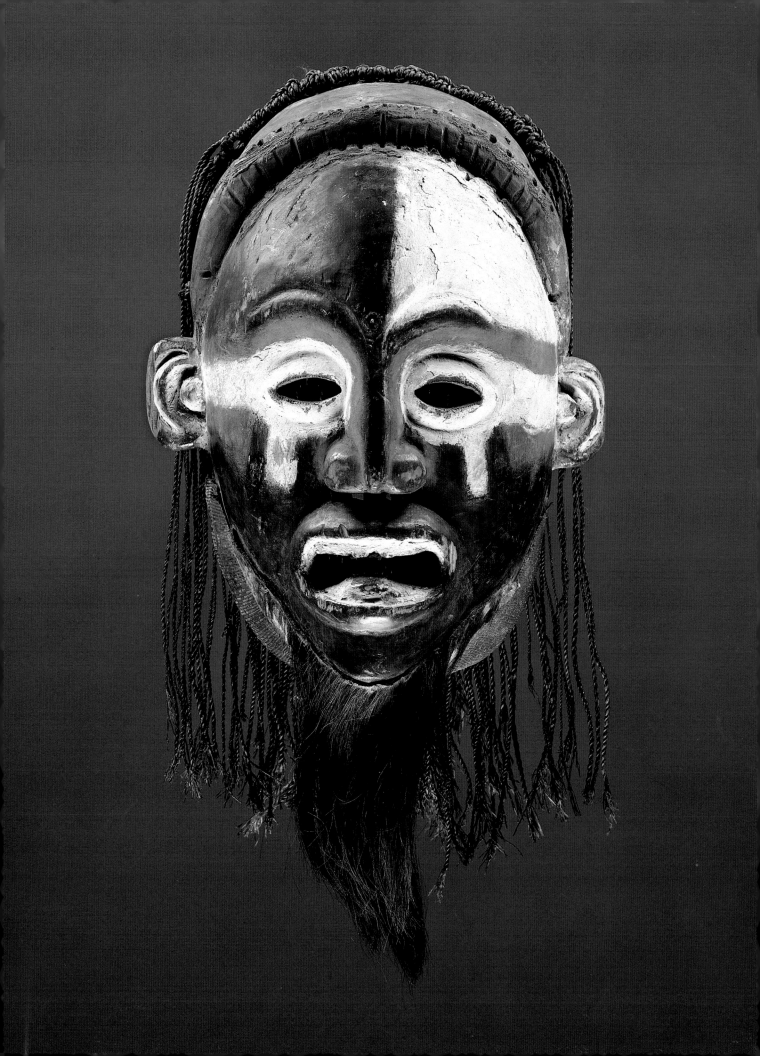

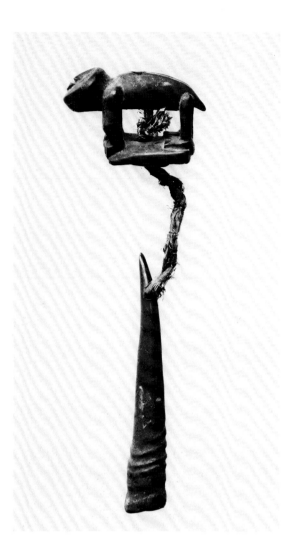

9. **WHISTLE: MONKEY**
 Congo; Vili, 19th century
 Wood, antelope horn, pigment, fiber,
 L. 11⅜ in. (29 cm.)
 Collected by the Loango Expedition, 1875
 III C 717a–c

This antelope-horn whistle is attached to two minia-
ture wood sculptures. One represents a walking mon-
key, whose nearly human head is cocked to the side;
the other, a cylinder, has two carved human faces. Al-
though the original catalogue records at the Berlin
Museum für Völkerkunde give the Yombe people as
the origin of this whistle, it may have been made by
the nearby Vili people (Maesen 1987). HJK

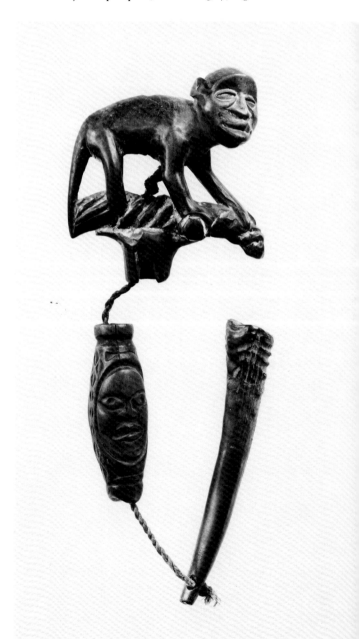

8. **WHISTLE: ANIMAL**
 Congo and Zaire; Sundi, 19th century
 Wood, antelope horn, cord,
 L. 7½ in. (19 cm.)
 Collected by Joh. Mikic, 1886 III C 3287

Along the lower Zaire River, whistles made of small
antelope horns were used in *minkisi* rites. Each whistle
had a small figure, usually quite ingeniously carved,
attached to it with twine. The tip of the horn is inserted
into a hole cut in the bottom of the figure. The carved
figures were considered to be magically potent and
were referred to as "children of the *minkisi.*" Such magic
whistles were reserved exclusively for ritual specialists
(*nganga*) and village chiefs. They were used in hunt-
ing and, most important, in performing rituals to
combat witches or—much the same thing—heal the
sick (Söderberg 1966). HJK

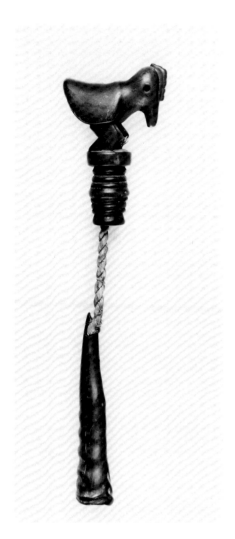
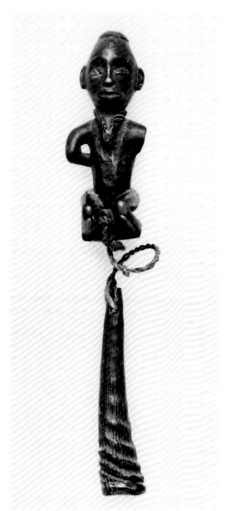
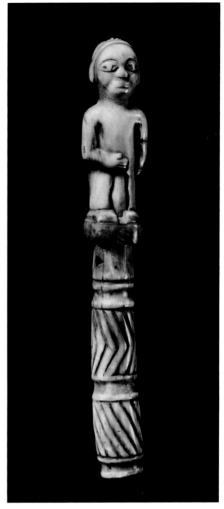

10. WHISTLE: BIRD

Congo and Zaire; Sundi, 19th century
Wood, antelope horn, cord,
H. 8⅝ in. (22 cm.)
Collected by Joh. Mikic, 1886 III C 3286

Figures of birds, as well as animals such as antelopes and dogs, are attached to Lower Zaire magic whistles to represent attributes, such as speed and strength, of the *minkisi* with which they are associated. HJK/KE

11. WHISTLE: MAN

Congo and Zaire; Sundi, 19th century
Wood, antelope horn, cord,
L. 9⅞ in. (25 cm.)
Collected by Joh. Mikic, 1886 III C 3285

The kneeling man depicted on this whistle may represent a prisoner or a slave (Söderberg 1966:16). His right arm is behind his back, hand clenched in a fist; the left arm is broken. HJK/KE

12. WHISTLE: MAN

Congo, Loango; Kongo, 19th century
Ivory, cord, H. 6 in. (15.2 cm.)
Gift of Robert Visser, 1901 III C 13754

Although carved entirely in ivory, this whistle faithfully imitates the form of Lower Zaire antelope-horn whistles with carved wooden finials. Incised with diagonal grooves suggesting the spiral ribs on real antelope horn, the hollow "horn" is inserted up to the head of the hollow figure of a standing man. It is removable, but a cord tied to its tip connects it to the figure. HJK/KE

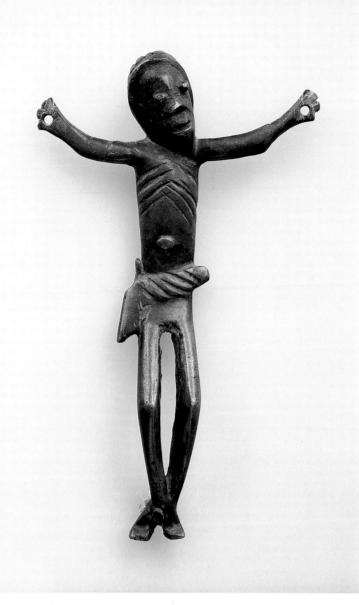

13. CRUCIFIX
Congo and Zaire; Kongo, possibly 17th century
Copper alloy, H. 6⅝ in. (17 cm.)
Purchased, 1986 III C 44073

Roman Catholicism, introduced by Portuguese missionaries, became the official religion of the Kongo kingdom at the beginning of the sixteenth century. Crucifixes of European type were copied and gradually Africanized by local artisans (Wannyn 1961; Thornton 1983). This crucifix retains the bodily proportions of its European prototype, though the face is African. Such figures were widely used as hunting charms, and for that purpose bundles of medicines, invariably removed by collectors, were once attached. WM

14. IVORY PLAQUE WITH CHRIST AND KNEELING FIGURES
Congo, Pointe Noire; Vili, 19th century
Ivory, H. 3⅜ in. (8.5 cm.)
Acquired from Klingelhöfer, 1874 III C 585

Belief in Christianity was most often combined with indigenous religious concepts and practices. On this small ivory plaque, two figures touch Christ, possibly reflecting African attitudes toward the dead. This gesture not only expresses sadness but may also show that they are not responsible for this death (Thiel and Helf 1984:109). HJK

15. TONI MALAU: SAINT ANTHONY WITH CHRIST CHILD
Congo and Zaire; Kongo, possibly 19th century
Wood, H. 20⅛ in. (51 cm.)
Purchased, 1986 III C 44072

Saint Anthony was much venerated by the Kongo from the sixteenth century onward. In 1704 a young woman named Kimpa Mvita, baptized Beatrice, declared herself possessed by the saint's spirit and began a movement to restore the Kongo kingdom that had been destroyed in 1665. She was convicted of heresy and burned at the stake. Figures of the saint were sometimes used as healing charms and were called Toni Malau, "anthony of good fortune." WM

The depiction of children in African art is often suggestive of fertility, and figures of Saint Anthony with the infant Christ came to be used in fertility rites among the Kongo. The Christ child has negroid facial features and holds a fly whisk, a symbol of leadership. The saint's wreath of hair is composed of ornamental patterns seen on other Kongo objects. HJK

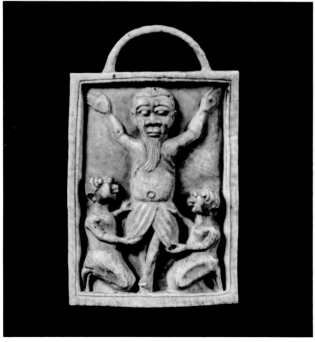

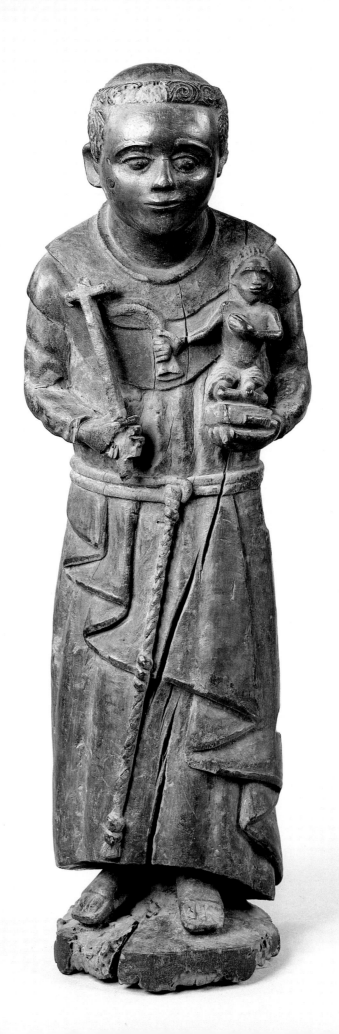

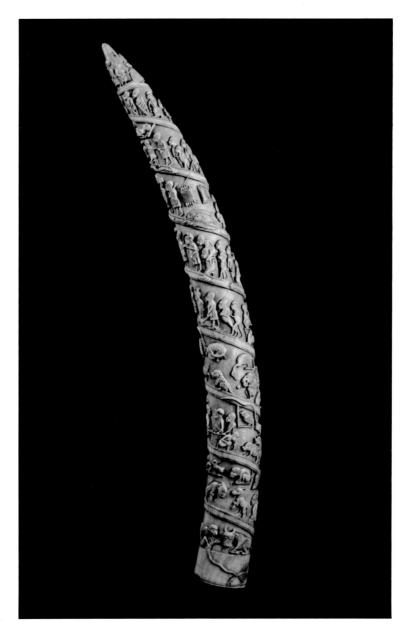

16. CARVED ELEPHANT TUSK
 Congo, Loango; Vili, c. 1870s
 Ivory, H. 26¾ in. (68 cm.)
 Collected by Adolf Bastian, 1874 III C 429

The coastal Vili state of Loango, independent of central Kongo authority since at least the seventeenth century, rivaled Kongo and Luanda in its commerce with Dutch, French, and other European traders and missionaries (Thornton 1983; Hilton 1985). Figurative ivory trumpets and staff tops served as symbols of authority for Loango rulers, as they did elsewhere in the Kongo region. Tusks such as this one, however, were nonfunctional; carved in Loango from the 1870s through the 1920s, they were made for Europeans as prestige souvenirs. This early example includes the standard spiral band that acts as a groundline for a procession of human and animal figures seen in profile (see fig. 6). The spiraling pattern has a long history in the Kongo region; laterally blown ivory trumpets from the sixteenth century show similar spiraling bands, though without figurative decorations. The parade of figures and the narrative format, uncommon in African art, were an apparent response to foreign market demands. This tusk includes figures both of power-holders and captives, but it emphasizes animal imagery and dualism: pairs of fish, monkeys, crocodiles, crabs, birds, and pigs occur, both copulating and quarreling in a mirror of human behavior. The uppermost band includes a European seated at a table across from a woman, possibly his wife, with the conical Kongo hairstyle but in European dress, and a boy, possibly his son. Such explorations of the relationships between the Vili and Europeans in the nineteenth century enrich the imagery of these tusks made for export. KC

40

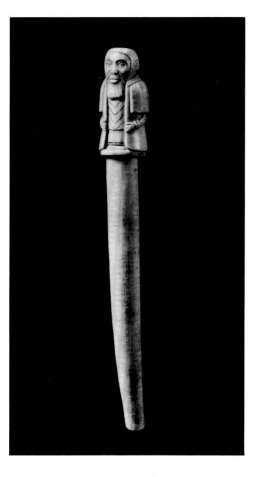

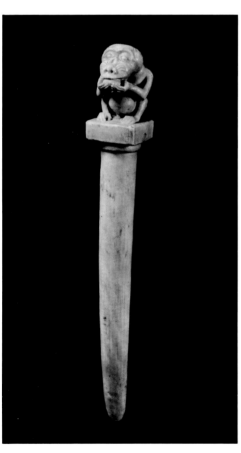

17. HAMMOCK PEG: MAN

Congo, Loango; Kongo, 19th century
Ivory, H. 10 in. (25.5 cm.)
Purchased from Mayer-Puhiera, 1906
III C 20536

18. HAMMOCK PEG: MONKEY

Angola, Ambriz; Kongo, mid-19th century
Ivory, H. 9¼ in. (23.5 cm.)
Collected by Oskar Lenz, 1877 III C 1102

Nobility in the Kongo region long favored travel by palanquin, even over short distances. As Filippo Pigafetta, a sixteenth-century traveler, observed, "Lying down in a sort of litter, or seated in them, and protected from the sun with umbrellas, the people are carried by their slaves, or else by men who are stationed at various posts for hire" (1591/1969:51). Ivory pegs such as these two served as prestigious additions to the hammocklike litters and were probably inserted in cross-supports.

The figure in European dress (cat. no. 17) is possibly a Catholic priest. Although his long, straight beard is emphasized, his facial features are not particularly alien in character. This lack of distinction between European and African features has elsewhere marked a degree of social integration in contact areas (Curnow 1989). In Loango, over two centuries of interaction with Europeans may have resulted in such a depiction. Alternatively, the figure may simply represent an African or Eurafrican cleric, many of whom were consecrated in the Kongo region.

The squatting monkey, food held to the mouth (cat. no. 18), is a motif found on a number of nineteenth-century ivory works throughout the Kongo region (see Pechuel-Loesch 1907:75) and is probably metaphorical. This peg is from Ambriz in the southern Kongo region, a trading port developed in the seventeenth century by the British and French to compete with Portuguese Luanda. KC

19. STANDING FIGURE

Zaire; Suku or Mbala, 19th–20th century
Wood, H. 24⅜ in. (62.5 cm.)
Purchased, 1986 III C 44920

Suku and Mbala charm figures are associated with particular *bisungu mikisi*, or "great" medicines owned and cared for by a given family lineage. *Bisungu* originate when some type of transgression enters lineage blood as a whole, and one of the lineage members is "seized."

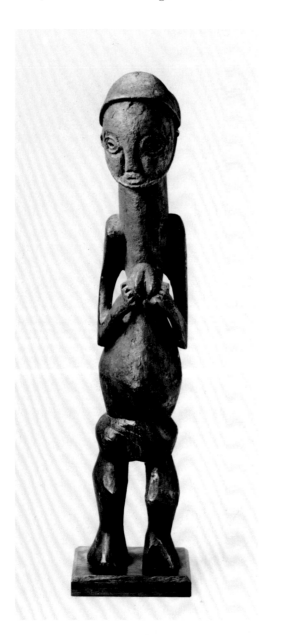

This is revealed by a diviner as the manifestation of a particular charm-curse, which the lineage must ritually contain, also observing its rules. The ritual and its accompanying paraphernalia are associated with the past curse that resulted in sickness or death and with the threat of future recurrences. Among the Northern Suku and their neighbors, there are some twenty possible charm-curse, or *bisungu*, institutions.

This rather tall charm figure bears a certain affinity to other examples from the easternmost Suku and southernmost Mbala around the locale of Meni Kongo (see, e.g., Lamal 1965: fig. 10; Musée Royal de l'Afrique Centrale, Tervuren, acc. no. 49.39.3). Suku statuettes have been categorized into several styles (Maesen 1959; Weyns 1960). Some resemble sculpture of their Yaka or Mbala neighbors, others form separate groups distinguished by the swelling lower torso, facial features, caps, or hairline treatment. It is difficult to equate these styles with particular regions, although they may reflect the work of individual carvers. AB

20. POWER FIGURE

Zaire; Hungaan, 19th century
Wood, horn, cord, H. 15¾ in. (40 cm.)
Collected by Richard Kund and Hans
Tappenbeck, 1886 III C 3310ab

High, crested, and lobed headdresses characterize Hungaan figure carving. The body form is similar to that of Suku and Yaka statuettes. This elaborate example balances a vessel above its head and carries a dog bell, horn container, and ten miniature figurines around its waist. The miniatures appear to represent "children" of the larger figure.

Hungaan carvings were associated with ritual experts (*nga* or *nganga*) specializing in protection, healing, and divination according to a particular ritual institution and involving a prescribed initiation. The Hungaan believed that objects were empowered in part by the dead whose souls resided in at least some of these objects (Engwall n.d. cited in Biebuyck 1985–86, 1:155–56). Larger figures were placed upon a high table within a house, and the largest were termed grandfather or grandmother *mukisi*. Those termed *nkonki* protected houses, gardens, animals, traps, and nets while others were worn by women and children as personal guardians or were hung over doorways.

This renowned example was collected in 1886 by the explorers Richard Kund and Hans Tappenbeck, the first Europeans to cross the Kwilu region. AB

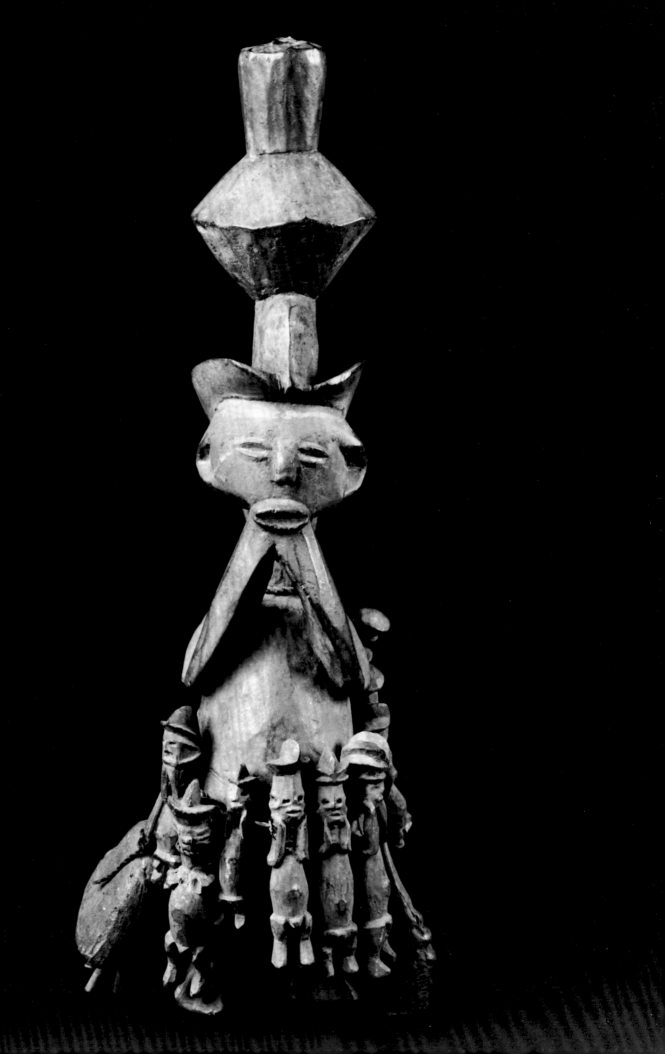

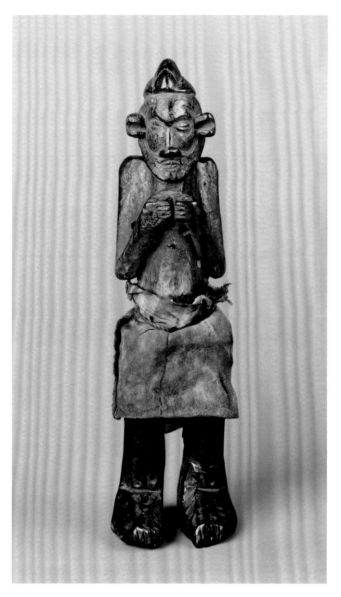

or chickens are then sacrificed and both the *bisungu* and lineage ancestors are invoked. Blood from the sacrifice is smeared on the forehead of each lineage member, the animal is cooked, and all share in the meal. If the afflicted person has been under treatment, he or she is ritually washed in the river, dressed in new garments, given a new name, and returned to the village amid dancing and singing. Although there is no absolute way to distinguish by style the particular *bisungu* context without accompanying documentation, statues made for *nkosi* are generally the tallest, while those for *mbaambi* and *mbwoolo* are much shorter. Small packets or antelope-horn containers are frequently suspended from the arms. This example, with its expressive rendering of the ears and crescentlike hat, is somewhat similar to the carving of Yaka neighbors to the west. A cloth covering or loose fiber skirt reflects the decorum sometimes given to female representations. AB

21. STANDING WOMAN
Zaire; Suku, 19th–20th century
Wood, cotton cloth, H. 12⅝ in. (32 cm.)
Purchased, 1986 III C 44828

Among the Suku, *bisungu*, or charm-curse, paraphernalia includes a packet of ritually prepared ingredients and only occasionally a wooden statuette. Because of the ritual complexity required in using and taking care of a particular *bisungu*, a specialist is brought in and one or more guardians (*kilunda*) are appointed. Young attendants are assigned to help the *kilunda* during the period of isolation, and a small dwelling is provided. The *kilunda* are taught specific prohibitions (*sasula*) as well as songs, dances, formulas, and ritual procedures. The paraphernalia is prepared by the specialist and if the *bisungu* requires a statuette, this is ordered from a recognized carver. (Suku *bisungu* that use statuettes are *nkosi*, *mbaambi*, and *mbwoolo*.) Goats

22. STANDING FIGURE
Zaire; Suku, 19th–20th century
Wood, H. 11⅞ in. (30 cm.)
Purchased, 1986 III C 44829

Throughout this region of Zaire are found statuettes that share certain stylistic features. The head is joined to the body by a dowellike neck that may disappear into a flattened shoulder or expand without interruption into a bulbous torso. Arms encircle or edge the torso and may join above the chest, support the chin, or reach almost to the stomach. Hands touching the breasts, as in this example and cat. no. 19, are comparatively rare in the region although relatively common elsewhere in Africa. All these figures appear to represent elders in their role of mediating misfortune, sickness, and death, past or present.

This example of a Suku figure is stylistically linked to three known statuettes that appear to be carved by the same person: two are in the Kongo-Kwango Museum, Heverlee (acc. nos. 2854, 2855; Bourgeois 1984: no. 202), collected in the locale of Kingungi on the Lukula River in 1938, and the third is in the Institut des Musées Nationaux du Zaire, Kinshasa (acc. no. 72.257.13; Cornet 1975: no. 30). They are distinguished by their rounded details, the ridgelike formation of the oval eyes, the shape of the mouth, and projecting, almost beardlike chin. The pointed knees and flattened navel are also found on one of the Heverlee examples (acc. no. 2855). All of these features illustrate close kinship with Mbala sculpture. AB

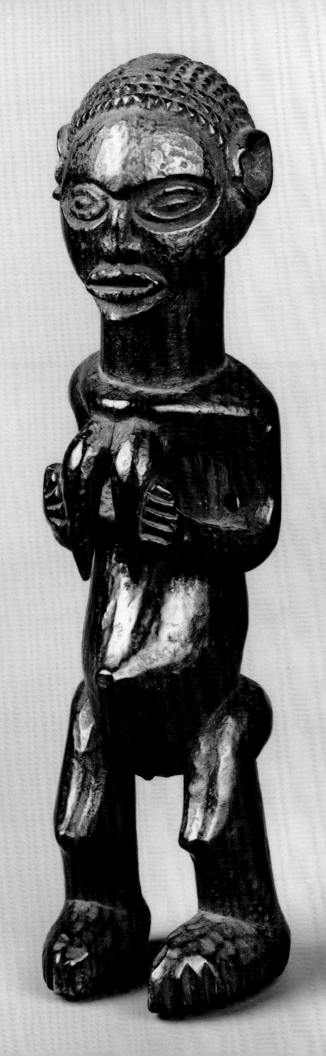

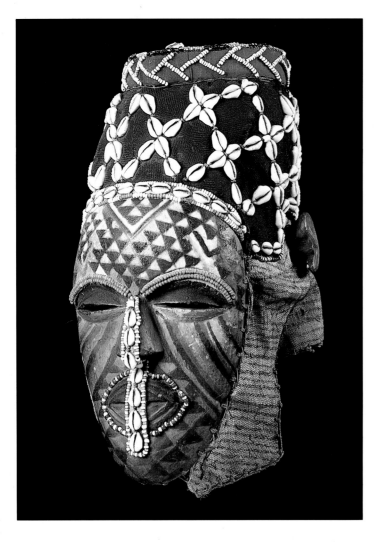

The mask is painted with geometric surface patterning, including triangles and parallel lines that run from just under the eyes to the jawline. These lines, characteristic of many Kuba masks, suggest tears which are shed at the death of an initiated man. The tears relate to the dominant context for many Kuba masks, their appearance at the funerals of deceased initiated men (Binkley 1987a). The hat worn by this mask is distinctive to Kuba female diviners. Its appearance suggests the mask's association with the world of nature spirits (*ngesh*) to whom Kuba diviners attribute their supernatural powers.

In performance, the masked dancer wears an elaborate costume consisting of a hide or barkcloth vest decorated with black and white triangular patterning. Attached to the vest are two small wooden pieces representing breasts. The dancer also wears gloves, slippers, and a decorated overskirt like that worn by Kuba women on ceremonial occasions. DB

24. MALE MASK (MULWALWA)

Zaire; Southern Kuba, 19th century
Wood, raffia fiber, paint, metal,
H. (without fiber) 21¼ in. (54 cm.)
Collected by H. Salomon, 1910 III C 26361

This mask is one of a variety of masks produced by the Southern Kuba, who share a common form of men's initiation. In performance, Mulwalwa is decorated with eagle and parrot feathers and wears an elaborate costume including a skirt of Colobus monkey skins. One or more examples of the mask without eyeholes, such as this one, are also placed on the peaks of an initiation wall (*lunda*) erected on one side of the village during the rite (Binkley 1987b; Vansina 1955). The hairstyle, pronounced nose, coloration, and geometric surface decoration of this mask are characteristic of other Southern Kuba helmet masks. The large conical eyes resembling chameleon eyes and the inverted pot atop the head identify it as Mulwalwa. The pot firmly places it within the sphere of male activities, as stacked pots are used by men to collect palm wine, which is consumed with relish during initiation-related activities. The addition of the pot also suggests that Mulwalwa may be inebriated and possibly dangerous to anyone who ventures too near. The unpredictable persona of this mask is evident during masked dances when a member of Mulwalwa's entourage controls its aggressive nature by restraining the masked figure with a rope tied firmly around its waist. DB

23. FEMALE MASK (NGADY MWAASH)

Zaire; Kuba, 19th century
Wood, cowrie shells, glass beads, paint,
raffia cloth, trade cloth, H. 13⅜ in. (34 cm.)
Purchased from Leo Frobenius, 1904
III C 19633

This mask is produced by a number of Kuba peoples and is borrowed from a northern Kete mask type, devoid of elaborate surface decoration, called *mukasha ka muadi*, which translates literally as "female mask." While most Kuba masks are considered to be masculine in gender, Ngady mwaash is the best-known female mask type. In the southern Kuba area, this mask performs with one or more male masks at dances held to honor deceased members of the initiation society. At the Kuba capital of Nsheng, Ngady mwaash forms part of a mask triad that includes the masks Bwoom and Mwaash ambooy mu shall. Some authors suggest their performance at the capital portrays the mythic origin of the Kuba peoples.

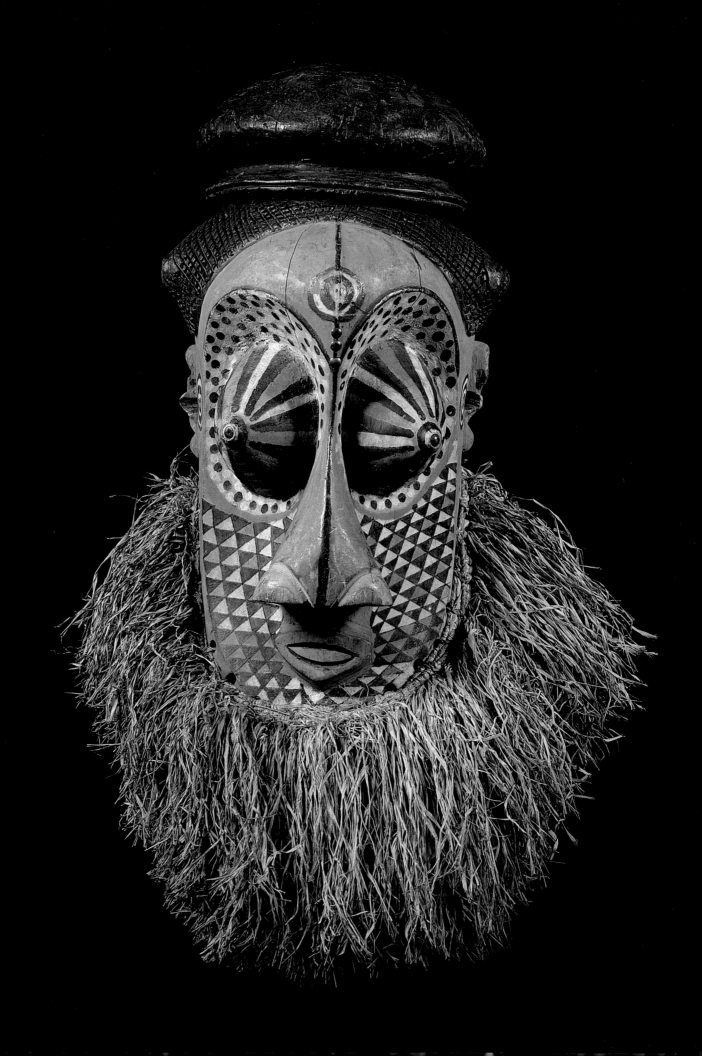

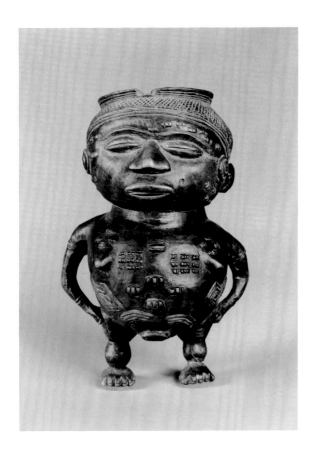

25. PALM-WINE CUP: STANDING FIGURE
Zaire; Kuba, 19th century
Wood, H. 6⅞ in. (17.5 cm.)
Purchased from Leo Frobenius, 1904
III C 19659

26. PALM-WINE CUP
Zaire; Wongo, 19th century
Wood, H. 7½ in. (19 cm.)
Purchased from Leo Frobenius, 1904
III C 19764

The most popular beverage among Kuba men and women is palm wine from raffia palm trees (*Raphia hookeri*). Wooden palm-wine cups were a high-prestige item in the nineteenth and twentieth centuries. Their use diminished only with the increased monetary value placed on older cups by Western collectors and by the introduction of serviceable replacements in metal or plastic.

The Kuba and neighboring peoples to the west, such as the Leele, Pende, and Wongo, produced cups that represented human heads or full figures such as the female figure with elaborate scarification patterning in cat. no. 25. Attenuated arms frame a swollen torso atop short squat legs. The style of this finely modeled cup is somewhat removed from core Kuba style. Kuba ethnographer Emil Torday attributed such cups to the "Kongo" (Wongo) peoples living to the west of the Kuba. Cups in a similar style are also known (Robbins and Nooter 1989: fig. 1111; Bastin 1984:338; Torday 1910:200), and similar circular scarification patterns on the temples have been attributed to Yaelima peoples who live to the northwest of the Kuba area (Maes 1924b: fig. 19).

Palm-wine cups made with or without handles usually have elaborately carved surfaces employing one or more patterns from the extensive Kuba decorative vocabulary. Cat. no. 26 represents an elaborately carved drum (see Brincard 1989:111) complete with an openwork base and a carved handle resembling a large hand surmounted by a human head or mask. The distinctive base also relates to prestige stool and drum forms produced by Northern Kuba groups. DB

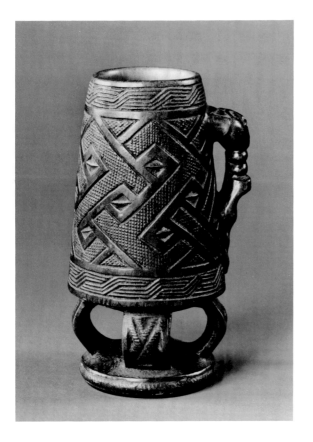

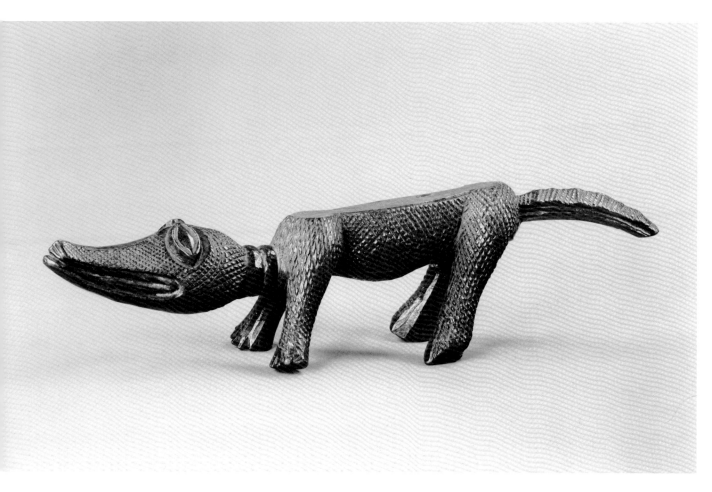

27. FRICTION ORACLE (*itoom*)
Zaire; Kuba, 19th century
Wood, L. 13 in. (33 cm.)
Purchased from Leo Frobenius, 1904
III C 19539

The Kuba and related peoples produced a group of small wooden sculptures called *itoom*, used in divination rites to detect witches, thieves, and adulterers and to determine the cause of illness or other misfortunes. *Itoom* were usually zoomorphic in form, with a smooth, flat surface on the animal's back on which a small moistened conical disc was placed by the diviner, who rubbed this disc and recited a series of names or formulas. The appropriate name or formula was revealed at the moment in the recitation when the moving disc abruptly stopped and adhered to the surface of the *itoom*.

Animals represented as *itoom* sculpture included the crocodile, bush pig, wart-hog, lizard, and dog. Forest animals were chosen because of their roles as divinatory intermediaries between man and the nature spirits (*ngesh*) who controlled fertility, prosperity, and healing and lived in the forest. Some *itoom* are very abstract and difficult to identify as a specific animal. This *itoom* probably represents a hunting dog. The hunting dog, while not a forest animal, was believed important because of its ability to negotiate the dark recesses of the forest and find hidden prey. This is analogous to the role of the diviner seeking truth through the manipulation of the *itoom* (Vansina 1958, 1978; Thomas 1960; Mack 1981). DB

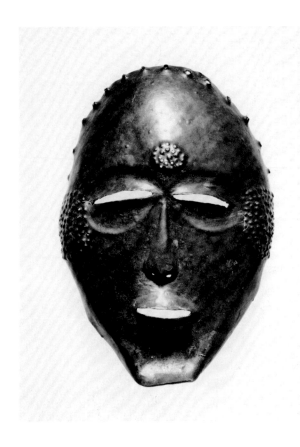

28. Mask

Zaire; Dinga, 19th–20th century
Copper, H. 11¼ in. (28.5 cm.)
Purchased, 1989 III C 44927

Among many peoples in Central Africa, the use of copper is largely restricted to regalia and important cult objects, such as the sheet-copper masks of the Dinga. These masks are characterized by slightly convex oval faces with understated, simplified features. Cut-out slits form the eyes and mouth, and the nose is in low relief. In this example, hammering around the eyes has created oval rings similar to those carved on Chokwe wooden masks. At each temple and in the center of the forehead is found a rosette of punched dots, representing decorative scarification marks. The Dinga (called Tukongo by their Chokwe neighbors) live in both Zaire and Angola along the west bank of the upper Kasai River, although their original homeland is to the east, near the upper Lomami River (Bastin 1961b; Felix 1987:30). Dinga hammered-copper face masks are called *ngongo munene*, meaning "great mask" or "chief's mask." They are worn only by high dignitaries on important occasions: funeral or commemorative ceremonies for the earth chief; the installation of his successor; ceremonies to propitiate the ancestors when a disaster threatens the village; or the initiations of adolescent boys. HJK/KE

29. Hunter

Angola; Chokwe, 19th century
Wood, human hair, fiber, glass bead, cloth,
H. 15⅜ in. (39 cm.)
Acquired from Otto Schütt, 1880 III C 1255

Among the major works of Chokwe art are figures that portray Chibinda Ilunga, a legendary hunter and culture hero, the son of a Luba king. According to oral tradition, Chibinda Ilunga left his homeland around 1600, married Lueji, a Lunda queen, and helped the Lunda to become powerful; as a result, the Lunda were able to impose their system of chieftaincy over Chokwe lineage heads. Chibinda Ilunga is also said to have introduced new and more efficient techniques and charms for hunting that established the Chokwe reputation as great hunters. During the mid-nineteenth-century surge in the ivory trade, their skill as elephant hunters allowed the Chokwe to expand their territory and power greatly. Among the Chokwe, Chibinda Ilunga is honored with images that portray him as a hunter. In this example, he wears the ornate headdress that identifies him as a chief, while he also carries hunting paraphernalia. He holds his gun and a staff in front of him, and attached to his belt are an axe, ammunition box, long-handled knife, calabash containing gunpowder, and a tortoise shell containing substances to ensure good hunting. Other hunting charms are strung on a band diagonally across his chest. Perched on his headdress and seated at his feet are small figures representing protective spirits who alert the hunter to the presence of game.

Chokwe sculpture is both refined and powerful. This figure's muscular shoulders, mighty hands and feet, and broad facial features convey a sense of power, while the delicately rendered details—down to the last fingernail—could not be more refined. HJK/KE

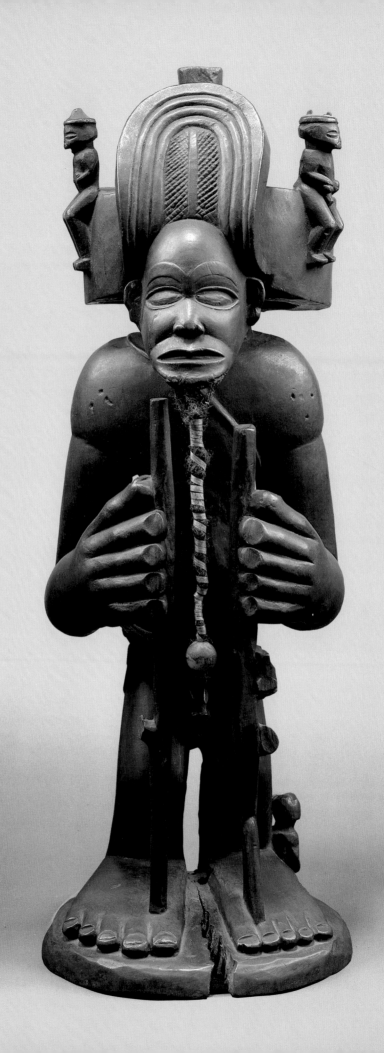

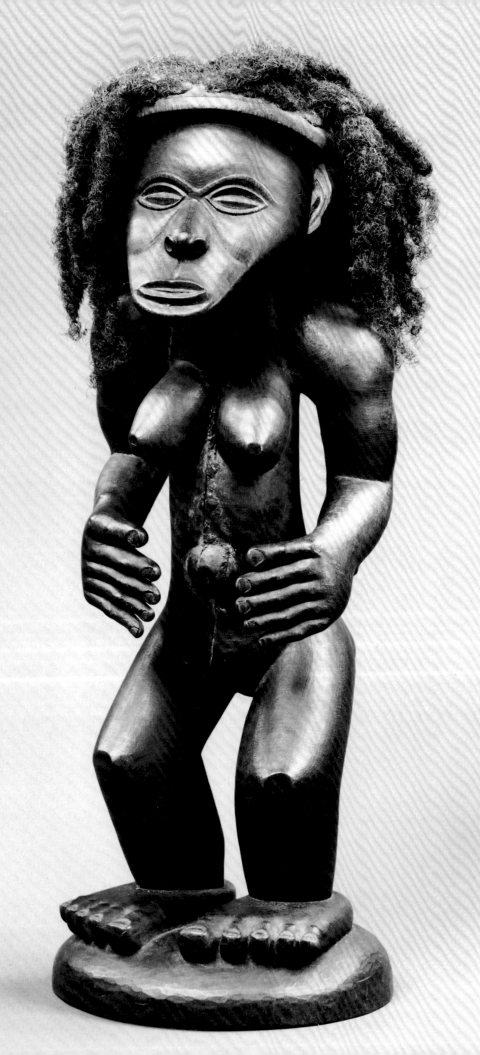

30. STANDING WOMAN

Angola; Chokwe, 19th century
Wood, human hair, pigment,
H. 13¾ in. (35 cm.)
Collected by Gustav Nachtigal, 1886
III C 2969

Chokwe female figures may reflect the important role women played in the mid-nineteenth-century expansion of Chokwe power. Using the wealth they earned by selling ivory and beeswax, Chokwe men acquired wives among neighboring peoples, thus rapidly increasing both their population and their territory. In a matrilineal society such as the Chokwe, women are an important means of extending, transmitting, and solidifying power. This figure of a woman manifests the muscularity and vitality typical of Chokwe sculpture. Her powerful limbs break into the space around her in a series of backward and forward thrusting movements defined by the chin, shoulders, breasts, elbows, hands, buttocks, knees, and calves. In contrast to the rounded limbs bursting with life, the face appears flat and masklike, yet its features are depicted with the clarity and sharpness also characteristic of Chokwe sculptural style. HJK/KE

31. WOMAN WITH CONTAINERS OF FOOD

Angola; Chokwe, 19th century
Wood, human hair, glass beads, camwood,
iron, traces of copper sheets,
H. 23¼ in. (59 cm.)
Collected by Heinrich Kawen, 1883
III C 1886

This figure may depict the young wife of a Chokwe chief responsible for preparing his meals (Bastin 1981:93–94). In one hand she carries a pottery cooking bowl, and in the other, raised above her shoulder, is a covered basket like those used for serving cooked cassava. The artist has meticulously endowed her with all the marks of Chokwe beauty (see fig. 8). Her teeth, inset with iron, are filed to sharp points, and the tip of her tongue is visible. The ornamental patterns of thick, raised lines and delicate incised dots on her abdomen, chest, and lower back represent the two types of scars the Chokwe apply to young women to enhance the aesthetic and erotic qualities of their skin. The coiffure, made of actual hair, is an old style in which the fringelike locks are coated with red earth. A band of hair, called *kaponde*, frames the forehead, terminating in a beaded ornament on each side. Beads and a pendant, made from a European glass earring, are strung around the neck, and remains of copper sheets are still visible in the figure's eyes.

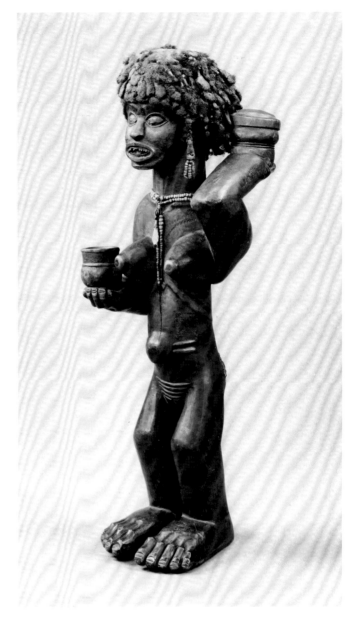

Chokwe figures are considered to be portraits of ancestors whose appearance is remembered through details of coiffure and scarification rather than facial features (Bastin 1976:19). Because of the cost, only chiefs and other notables could obtain these figures; unfortunately it is not known in what contexts they were used or where they were kept. HJK/KE

53

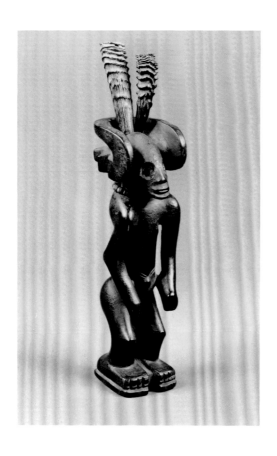

32. FIGURE

Angola; Chokwe, 19th–20th century
Wood, animal horns, glass beads,
H. 6⅝ in. (17 cm.)
Purchased from Hermann Baumann, 1938
(collected 1930) III C 37490

33. FEMALE FIGURE WITH HORN ON SHOULDER

Angola; Chokwe, 19th–20th century
Wood, glass beads, copper wire, sacrificial
materials, H. 8¼ in. (21 cm.)
Purchased from Hermann Baumann, 1938
(collected 1930) III C 37492

The Chokwe commission wooden sculptures representing deceased relatives, which they keep under the bed. When illness strikes, the figures are offered sacrifices to attract the ancestors to the sculptures and to ensure peace and tranquility. Magical ingredients are placed in the tiny horns inserted in the head (Baumann 1935:196, quoted in Krieger 1965–69, 1:124).

Cat. no. 32, collected in Namusamba village, is remarkable for its ambiguous sexuality. Although it is female, according to Baumann it represents a dead brother and is shown with the headdress associated with chieftaincy. Baumann collected cat. no. 33 in Mahakolo village and identified it as the image of a dead sister, commissioned by her brother (Baumann 1935: pl. 86, figs. 1, 1a). She holds an animal horn, probably also meant to contain magical materials. HJK/KE

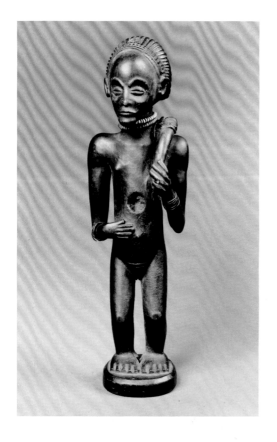

34. TOBACCO MORTAR: FEMALE FIGURE

Angola; Chokwe, 19th century
Wood, glass beads, cloth, human hair,
leather, calabash, H. 12¼ in. (31 cm.)
Acquired from Dr. Paul Pogge, 1877
(collected 1875) III C 975

Elaborate tobacco mortars were especially coveted as luxury articles by the Chokwe. In this one, the snuff container takes the form of a small drum balanced on a woman's head. She wears a chief's headdress, supplemented with locks of real hair, and has been identified as either the ruler's principal wife or his mother (Bastin 1981:91). Paul Pogge collected this on a Berlin Geographical Society expedition to the court of the Lunda ruler, the Mwata Yamvo, at Musumba, which he reached in 1875. Pogge was the first to record the tradition of Chibinda Ilunga (see cat. no. 29). HJK/KE

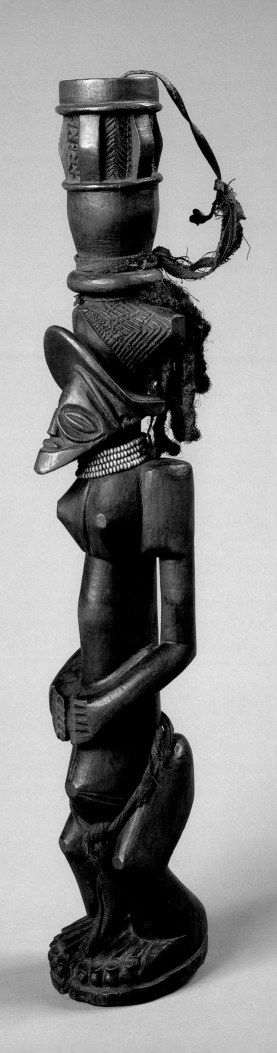

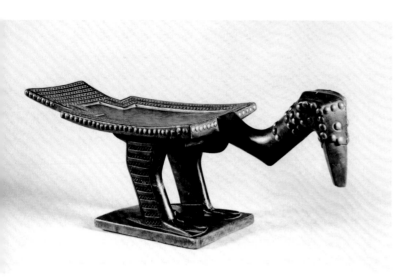

35. Bird-shaped Stool

Angola; Imbangala, 19th–early 20th century
Wood, brass tacks, L. 21¼ in. (54 cm.)
Collected by Gustav Aengeneyndt, 1932
III C 34406

The catalogue records at the Berlin Museum für Völkerkunde identify this stool in the form of a bird as "probably Mbangala." The Mbangala, or Imbangala, are located west of the Chokwe between the Kwango and Lui rivers. Like the Chokwe, the Imbangala state (also known as Kasenje) was founded by migrants from the Lunda empire in the seventeenth century. It controlled the trade between the Lunda and the Portuguese on the Atlantic coast throughout the eighteenth century but lost its monopoly to rival Portuguese and Ovimbundu traders by the middle of the nineteenth.

The Chokwe penchant for elegant utilitarian objects profusely covered with incised patterns is evident in the rows of zig-zags that decorate this Imbangala stool. Like many Chokwe works, it also incorporates brass tacks, one of the commodities obtained through trade with the Portuguese. Similar bird-shaped stools and smaller versions used as head rests are known among the Chokwe (Bastin 1961a: pls. 153, 165, 166). HJK/KE

36. Staff

Angola; Chokwe, 19th century
Wood, brass tacks, H. 12⅝ in. (32 cm.)
Acquired from Alexander von Homeyer,
1876 (collected 1875) III C 778

Chokwe chiefs are descended from the Lunda nobles who imposed their system of rulership over the Chokwe in the seventeenth century. Among their insignia of office are carved wooden staffs depicting a past chief

(Miller 1969:14). In this renowned example from Berlin, the chief's broad, fleshy face is framed by an elaborate headdress and an ornately shaped panel covered with incised designs. The headdress is of a type worn only by great chiefs; versions are known in beaten copper and in cloth-covered basketry (Bastin 1982:77). The tiny antelope horns depicted on the back of the headdress held magical ingredients and indicated the importance of occult knowledge to the chief's power.

This staff was acquired by Alexander von Homeyer, an ornithologist who headed the expedition to the Mwata Yamvo's court on which Dr. Pogge collected the Chokwe tobacco mortar (cat. no. 34). However, von Homeyer became ill and returned to Europe before entering Chokwe territory, indicating that he must have acquired this masterpiece of Chokwe court art from the hands of a trader. HJK/KE

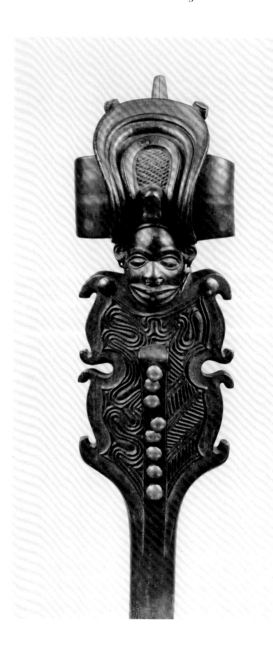

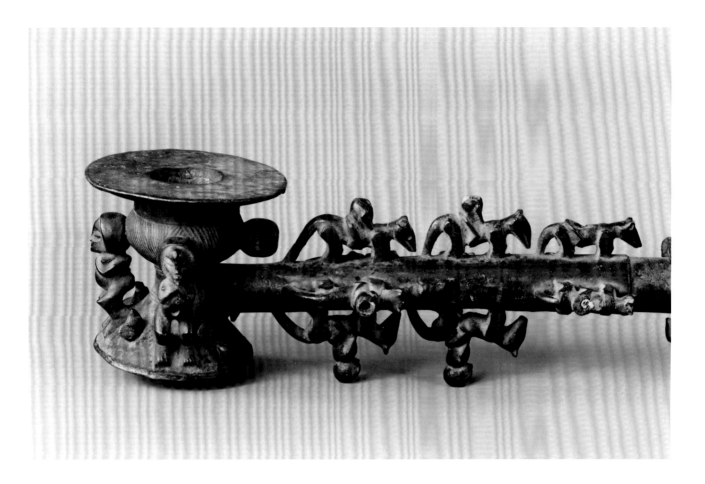

37. PIPE

Angola; Bondo, 19th–early 20th century
Wood, iron, brass sheets, L. 41 in. (104 cm.)
Purchased from Marianne Martens, 1934
III C 34419

Little is known about this pipe other than that in the
Berlin museum records it is said to have been acquired
from a Bondo chief named Socola. The Bondo are an
ethnic group located west of the Imbangala, north of
the Songo, and south of the Holo. The pipe's long
stem and round bowl with conical base and wide, flat
rim, are similar to forms used by the Songo and Holo
(Bastin 1969:54; Bastin 1979:41; Lecluse 1985, 2:546,
548–551). Along its stem and around the bowl are tiny
figures, standing and on horseback, as well as birds
and other animals, all carved almost fully in the round.
They are highly reminiscent of the lively figures carved
on the rungs and backrests of Chokwe chiefs' chairs
and attest to the strong influence the Chokwe exerted
on the arts throughout northeastern Angola. Elabo-
rately decorated pipes such as this were prized by
wealthy and powerful people throughout Africa. HJK/KE

38. WARRIOR

Zaire; Lulua, 19th century
Wood, pigment, H. 29⅛ in. (74 cm.)
Collected by Hermann von Wissmann,
1885 III C 3246

Lulua sculpture is elegant and graceful, distinguished from the art of neighboring peoples by its emphasis on details and profuse surface ornamentation. This figure depicts a warrior well equipped for both physical and spiritual battles. He holds a ceremonial sword and shield and carries a calabash. A bag hangs at his side; knives and other paraphernalia are hung from his belt, which secures an apron worn only by chiefs and made of the skin of a spotted cat, symbol of vital forces and majesty. On his chest hangs a power object in the form of a crouching figure, and over his left shoulder is an amulet made of carved buffalo horn.

In their sculpture, the Lulua concentrate on physical beauty, which they believe is an expression of inner strength and character, providing protection against evil (Maesen 1982a:53–54). Their concern for personal beauty is reflected in their sculpture. The figure's face and neck are decorated with textured patterns that depict the slightly raised and darkened scars the Lulua wore until the end of the nineteenth century (see fig. 7). His hair is elaborately coiffed; even his beard and moustache are intricately plaited. In their pursuit of beauty, the Lulua commonly anoint themselves and their sculpture with a mixture of red wood powder and oil or water. In this example only half the face has been treated in this way.

At the time it was collected by Hermann von Wissmann and his companion Ludwig Wolf, this figure, called *makuba buanga*, stood on a grave and served as a power object (Krieger 1965–69, 1:120). According to other reports, such figures accompanied warriors into battle, giving them courage and moral support (Timmermans 1966:18), and revitalized the power of a chief in a cult called *buanga bua bukalenge* (Maesen 1982a:52).
HJK/KE

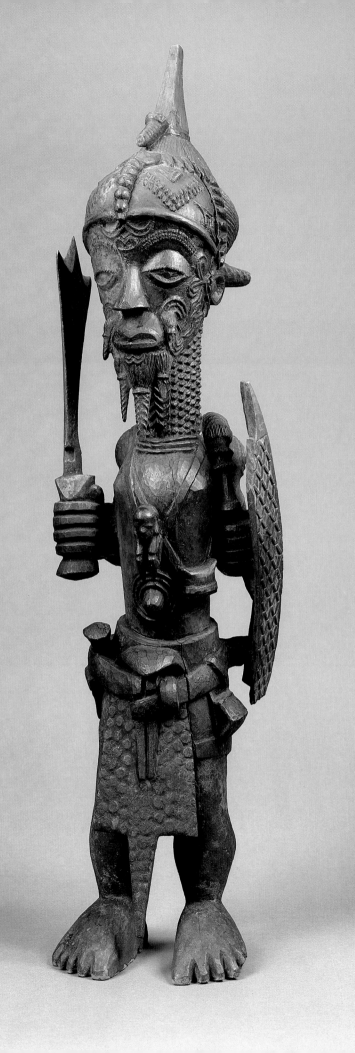

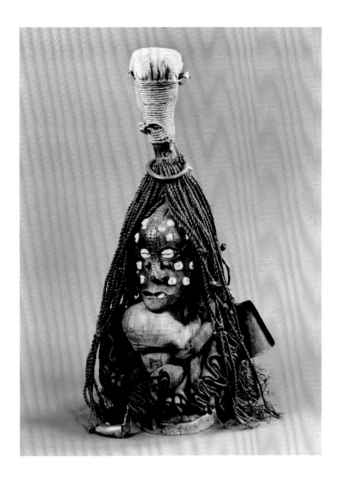

39. POWER FIGURE

Zaire; Songye, 19th century
Wood, raffia cloth, braided and twisted cord,
animal skin, brass sheet, brass tacks, cowrie
shells, human teeth, iron bell, cotton cloth,
sacrificial materials, H. 19¼ in. (49 cm.)
Purchased from Leo Frobenius, 1904
III C 19593

The range of figural forms, levels of craftsmanship,
and external paraphernalia of Songye sculpture are
particularly pronounced in private power figures.
These intimate, individualized objects were not nec-
essarily works of renowned carvers and ritual experts,
as is the case with sculptures for the community. Their
diverse uses constitute a kind of anonymous Songye
tradition, unlike some village *mankishi*, as the Songye
call power figures (singular, *nkishi*), whose outstanding
feats remain part of local history (Hersak 1986:121).

The function of this rather large personal *nkishi*
cannot be determined by its appearance alone. The
"medicines" (*bishimba*) inside the horn on top of the
head and in the abdominal cavity allude to the aggres-
sive nature of the piece. There are two sets of sym-
bolic components: parts of ferocious animals allude
metaphorically to violent action; strands of hair and
nail clippings from the user are metonymic expressions
of the desired action (Hersak 1986:129). The varied
external paraphernalia, such as raffia cloth, cord, di-
verse metal objects, animal skin, and cowrie shells, aug-
ment the visual power of the figure (Hersak 1986:130).
Despite possible contextual and regional differences
in interpretation, the metal appliqué suggests sorcery
as found in the central Songye region, while the teeth
might bear an association to witchcraft as among the
Bala (Merriam 1974:214).

In contrast to more angular central Songye works,
this sculpture belongs to a stylistic corpus typified by
the curvilinear, skeletal form of the head. In the Mu-
seum of Mankind in London there is a group of stylis-
tically comparable examples, one of which is very
similar (acc. nos. 1908, 6–22, 159). These pieces were
collected by Emil Torday whose accounts of the Songye
relate mainly to the Tempa region (Torday 1910:28;
Torday and Joyce 1922:26, 27). DH

40. POWER FIGURE

Zaire; Songye, 19th century
Wood, mammal skin, lizard skin, iron, raffia
cloth, leather, feathers, H. 9½ in. (24 cm.)
Purchased from Leo Frobenius, 1904
III C 19591

The geometrical and predominantly angular treatment
of the carving, the protruding, bulbous cranium, flat
shoulders, and voluminous, squat body identify this
power figure (*nkishi*) as coming from the Kalebwe, a

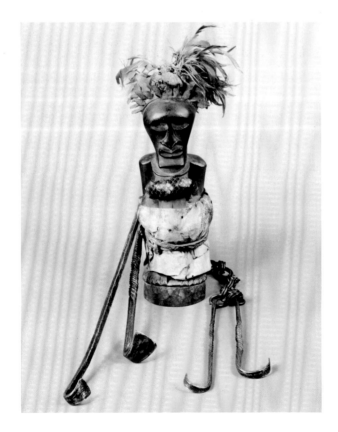

once-powerful central Songye chiefdom. Given its small size, it was undoubtedly used for protection by an individual. Otherwise, it is similar to large Kalebwe community figures, whose stylistic homogeneity influenced the carving of personal figures as well as *bifwebe* masks throughout the central Songye region (Hersak 1986:150).

In most Kalebwe works, the arms are drawn tightly to the torso, hands over the abdominal protrusion containing the power substances (*bishimba*; Hersak 1986: 140–150). Belts, frequently made of lizard skin, are drawn through holes in the underarm area. Metal rods and gouges for the manipulation of the *nkishi* are attached to such belts (Hersak 1986:146, 154). Animal components, such as antelope horns, fur, or skin and feathers, as on this carving, suggest behavioral characteristics that relate metaphorically to the strength and dominance of leaders and dignitaries (Hersak 1986:130). The arrangement of feathers on this figure recalls headdresses worn by certain Songye chiefs (Hersak 1986:18). The metal blades that edge the headdress refer to the blacksmith, a culture hero, whose role is celebrated in a Kalebwe myth of state formation (Hersak 1986:12–15). All of these external attributes contribute visually to sustaining the belief in the power and efficacy of the *nkishi*. DH

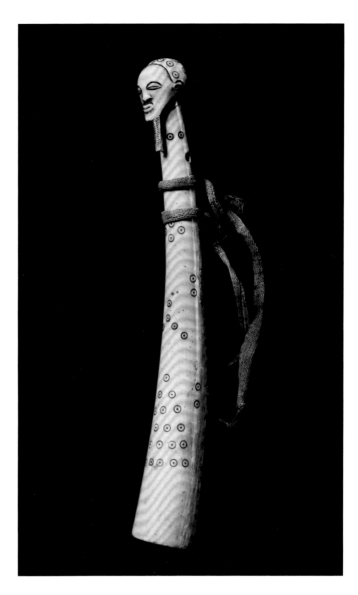

41. HORN WITH HUMAN HEAD

Zaire; Songye, 19th century
Ivory, abrus seeds, cowrie shells, wax,
sacrificial materials, raffia cloth,
L. 15 in. (38 cm.)
Collected by Hermann von Wissmann,
1883 III C 1824

This ivory horn, with its delicately carved head, was collected in 1883 by Hermann von Wissmann during his first expedition with Paul Pogge through Central Africa (1880–83). Its provenance (noted as "Russuna"; Krieger 1965–69, 3:74) is probably the village of Lusuna among the Malela, a Kusu group just north of Songye territory, which the expedition visited en route to Nyangwe (von Wissmann 1890a:163, 164).

The Malela comprise an admixture of Kusu and Songye people although they have also been influenced by the Luba and Hemba (Boone 1961:92). The heterogeneous features of this horn seem to reflect the mixed ethnic composition of this region, especially in the late nineteenth century when Nyangwe was a major Arab trading post for ivory and slaves (Biebuyck 1985– 86,2:235; Merriam 1974:8). Stylistically, the cowrie-shaped eyes, crescent ears, full lips, and prominent forehead and chin of this piece recall Songye characteristics. However, the roundness of facial form and contained proportions also relate it to Luba, Hemba, and Kusu traditions. Kusu carvings, which

do include some works in ivory, often have ovoid faces that are bearded as this one is (Felix 1987:66). The circle-and-dot motif is a design element probably inspired by traditions of the peoples to the north of Nyangwe who share Lega cultural elements. This motif, so common on Lega ivories, may be purely decorative, devoid of meaning (Biebuyck 1985–86,2:5).

Given the rarity of Songye objects of this type and material and the general lack of data on the art traditions of groups northeast of the Songye, little can be said with certainty about the contextual use of the piece. A similar piece (Musée Royal de l'Afrique Centrale, Tervuren, acc. no. 24181) was identified by the Songye as a *mpungi*, a horn blown to announce a chief (Hersak 1978). Both this piece and the Tervuren horn have a hole below the head for suspension, but on this example the open end is filled with wax, abrus seeds, and other substances, suggesting that it was used as an object of regalia, possibly endowed with magical attributes. DH

61

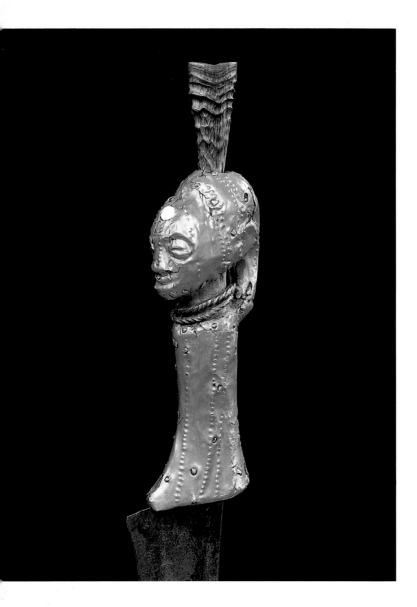

pedition to Yanouge on the Lualaba River. Wolf replaced von Wissmann as leader and acquired numerous objects among the "Bena Lussambo" (von Wissmann 1891:50; von Wissmann et al. 1891:254, 255). The Berlin Museum's catalogue confirms that the piece was collected on the right bank of the Sankuru, at the mouth of the Lubi (not Subi) River (Krieger 1965–69, 3:70). The area of Lusambo is inhabited by the Luba and Tetela (Boone 1961:118, 226). DH

43. POWER FIGURE
Zaire; Songye, 19th century
Wood, brass tacks, sheet brass, lizard skin,
iron hooks, tooth, fiber, fur, leather,
H. 7⅛ in. (18 cm.)
Collected by Hermann von Wissmann,
1883 III C 1792

In the Songye region a variety of power objects, especially power figures (*mankishi*), predominantly male, are used to activate benevolent spirits to help an individual or entire village to combat illness, infertility, and other misfortunes, or to achieve other goals. The figural form is mainly a receptacle for "medicinal" ingredients: animal, vegetal, and mineral substances that are placed in the abdominal cavity or head, often in a horn pegged into the top of the skull. The *nganga*, or ritual specialist, endows the figure with these active, spirit-invoking ingredients and adds external paraphernalia to enhance the visual and symbolic impact of the figure. The *nganga* rather than the carver is credited with making the piece, as it is he who transforms it into a client-specific, functioning mechanism (Hersak 1986:118–122).

The profusion of brass tacks driven into this piece may allude visually to its ambivalent nature: it must cause injury to the evildoer in order to yield beneficial results for the user (Hersak 1986:131). The metal appliqué around the mouth and especially the strips attached to the temples and along the nose/forehead axis are characteristic of Songye statuary. Although the Songye are somewhat evasive about the meaning of these attachments, they may relate to the effect of lightning. This is undoubtedly a veiled reference to sorcery since lightning is attributed to practitioners of this malevolent craft (Hersak 1986:131).

The figures are carved in a wide range of sizes. Small pieces such as this one are used by individuals; large ones (about 3 feet high) serve a community. This figure bears many stylistic traits recurrent in central Songye carving, but its rounded facial form and the elongation and sensitive treatment of the body also align it with Luba sculpture. It was probably collected in the eastern part of Songye territory in the region of the Sanga or Eki which von Wissmann visited and documented (von Wissmann 1890a:139–145). DH

42. KNIFE: HUMAN HEAD
Zaire; Songye, 19th century
Wood, brass sheets, iron, animal horn, tooth,
L. 24¾ in. (63 cm.)
Acquired from Ludwig Wolf, 1886
III C 3543

The style of this knife with its round facial form on the handle corresponds to Luba aesthetic expression, though the use of the metal appliqué suggests the workmanship of Tetela smiths (Felix 1987:174). The horn, used to insert magical substances into an object, is more a Songye convention, however, and in this region the convergence of different ethnic groups clearly led to an admixture of visual elements. The piece may have been used as a regalia object by chiefs or warriors (von Wissmann et al. 1891:254, 255; Felix 1987:82, 174). It was collected in 1886 by Dr. Ludwig Wolf, a Belgian officer who was part of Hermann von Wissmann's ex-

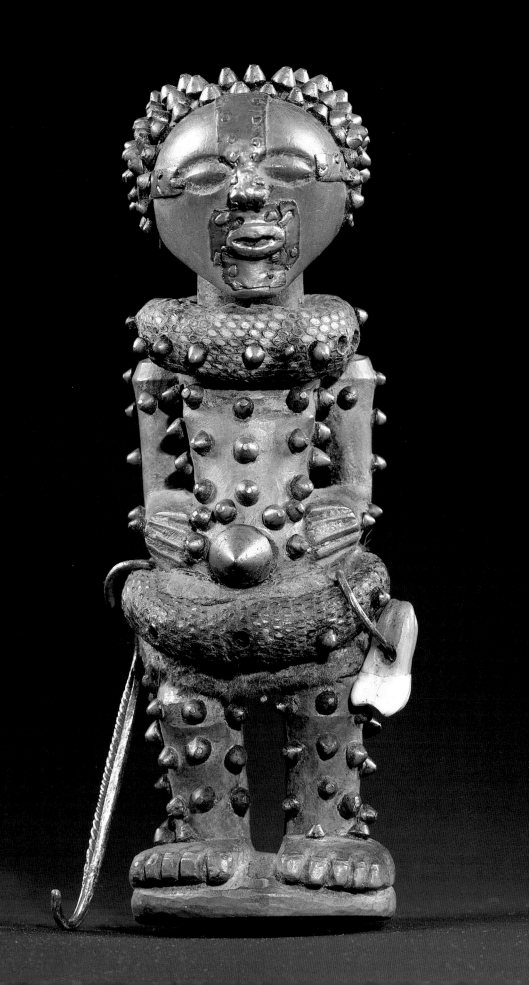

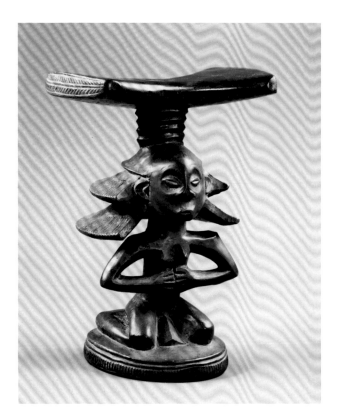

44. Headrest: Seated Woman
Zaire; Luba, 19th century
Wood, traces of pigment,
H. 7¼ in. (18.4 cm.)
Purchased from Leo Frobenius, 1904
III C 19987

Throughout Africa, wooden headrests are used as pillows to preserve intricate and labor-intensive hairdos. This example belongs to a series of headrests, one stool, and one *kashekesheke* divining instrument attributable to a single artist or workshop active in the nineteenth century. In addition to dynamic poses, most figures in this corpus wear a dramatic coiffure, inspiring Westerners to call this artist the "Master of the Cascade Coiffures" (Fagg and Plass 1964:88; Vogel 1980:137). This coiffure was especially popular around the villages of Kabondo Dianda and Busangu in the Luba-Shankadi area up to 1928. Styled over a canework frame, it took almost fifty hours to complete and, with the use of a headrest at night, it could last two to three months (Burton 1960:notes to painting no. 8). Luba hairstyles mark stages in a person's life. The purpose, however, is primarily aesthetic, and the Luba say that an elegant coiffure makes a woman's face radiant (Nooter 1990). The Luba value these headrests highly. When an important person died and the body was irretrievable, the deceased's headrest was buried instead. In the late nineteenth century, the Yeke, attempting to overthrow the Luba, burned Luba headrests, while leaving other objects intact (Maesen 1982b).
PN

45. Royal Cup: Human Head
Zaire; Kanyok, 19th–20th century
Wood, H. 6¼ in. (16 cm.)
Purchased from Hermann Haberer, c. 1925
III C 33231

The collection's files attribute this to the Lunda, but it is certainly a product of the Kanyok, a people related to the Luba. Royal cups (*musenge*) may be used by the Kanyok in a religious ceremony to honor paternal ancestral spirits (Maesen 1982b). During the ceremony a title-holder was designated to make an offering of cooked cassava, while the chief communed with the spirits. The chief counselor, whose title is Shinga Hemba, then drank palm wine from one side of the cup and passed it to all participants who drank from the other side. The ceremony was enacted after divination or at the time of a new moon (Maesen 1982b; Nooter 1984: 60–61).

This is a rare example of a cup in the form of a human head; most are rendered as nonfigurative drinking vessels divided into two identical halves. This one, "executed in the traditional Kanyok style with its soft and slender forms, . . . is likely from a workshop operating in the vicinity of Kandakanda in the first two decades of this century. The same workshop produced countless objects such as stools and ritual staffs destined as regalia for the chieftain. I [Albert Maesen] had the opportunity to view these things in his storeroom. The drinking vessels were the only objects I was not permitted to see, though I was shown the rectangular box in which they were kept. I was told that these drinking vessels were only used during the installation of the chieftain and on similarly important occasions" (Maesen 1987). PN/HJK

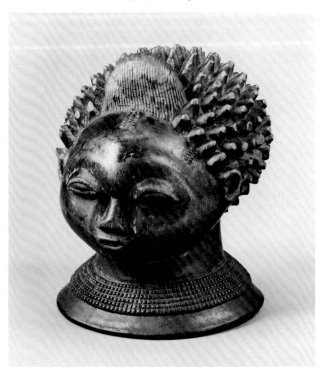

46. Double Cup: Human Head
Zaire; Kalundwe, 19th–20th century
Wood, metal, W. 7⅛ in. (18 cm.)
Purchased from Hermann Haberer, c. 1925
III C 33233

Most Luba-related anthropomorphic cups known in the West come from the western frontier of Luba political influence. This cup bears a close resemblance to two other examples in private European collections and can be identified as Kalundwe on the basis of style (Felix 1987: 48–49). In Luba royal investiture rites of the past, the transmission of power to a new king required the consumption of human blood from the dried cranium of his predecessor. The head was considered to be the locus of power and wisdom, and blood was the sacrificial agent that rendered a king semidivine. Based on the life-size dimensions of these cups and the secrecy that surrounds them, it is thought that they may have replaced actual crania, thus making them among the most sacred of all Luba royal emblems (Van Geluwe 1982; Preston, Vogel, and Nooter 1985:75).

The gender of this striking head with its voluptuous coiffure cannot be determined with certainty, since *balopwe* (kings) are known to wear female coiffures on the day of their investiture. The chignons are ornamented with iron hairpins, whose purpose is to fasten in the spirit, assuring the cup's role as a receptacle for the king's sacral power (Nooter 1990). PN

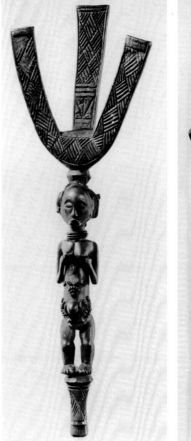
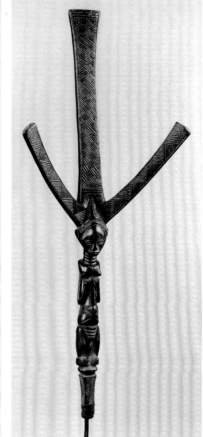

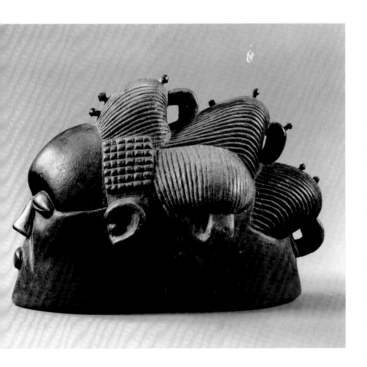

47. Bowstand
Zaire; Luba, 19th century
Wood, glass beads, L. 22¾ in. (57.8 cm.)
Collected by Hermann von Wissmann, 1883
III E 1591

48. Bowstand
Zaire; Luba, 19th century
Wood, iron, L. 30⅞ in. (78.5 cm.)
Purchased from Leo Frobenius, 1904
III C 20015

The great mythical culture hero of Luba kingship was a renowned hunter whose cherished possession was his bow. Although bowstands serve literally to hold bows and arrows, they are primarily symbols of chiefly authority subject to elaborate ritual and taboo. Never displayed in public, they were guarded in a special house by a female dignitary whose role was to provide prayers and sacrifices (Maesen 1982b). Both of these examples depict female founders of specific royal clans. The gesture of hands to chest refers to the Luba belief that women guard the secrets of royalty within their breasts. The metal shaft (visible in cat. no. 48) is a metaphor for the ironlike strength of a king's power. The patterns on the bowstands' branches are called scarifications, *ntapo*, and relate to royal prohibitions. Depicted on the base of the central branch in cat. no. 47 are two small antelope horns, receptacles for medicinal ingredients and associated with power, healing, and transformation (Nooter forthcoming). PN

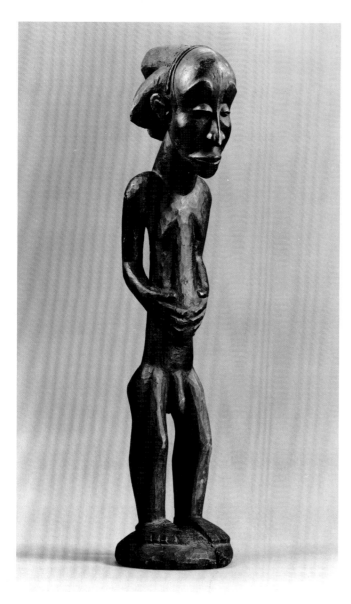

1830. It is said to have been carved by a sculptor named Ngonga ya Chintu who lived at Kateba, not far from Kankunde village. This information illustrates the mobility of art and artists in southeastern Zaire, and its ability to cross ethnic boundaries. Kankunde and Kateba are both about 60 miles from the town of Buli, where two of the sculptures in this style were collected, and their inhabitants are Hemba rather than Luba. Luba rulers sought out the most renowned artists to make their sculptures and other regalia, even if it meant traveling great distances.

This figure resembles Hemba figures in its standing posture and the placement of the hands on the swollen abdomen (see cat. no. 54). However, it is unclear whether, like Hemba figures, it represents a specific ancestor whose image is preserved by chiefs and clan heads. HJK/KE

49. MALE FIGURE

Zaire; Luba, 19th century
Wood, H. 32¼ in. (82 cm.)
Gift of Göring, 1903 III C 16999

The Buli style is evident in this figure of a standing man, one of only two in the Buli corpus. The Berlin Museum has only minimal information about this figure, but fortunately there exists collection data concerning the other male figure in this style which may ultimately help to provide an identity for the anonymous Buli Master. The other figure, which is almost identical to this one, was collected in a village called Kankunde east of the Lualaba River and south of the Luika River (Neyt 1977:318–321). According to the genealogy provided by its last guardian, it was made about

50. STOOL: TWO FIGURES

Zaire; Luba, 19th century
Wood, H. 21¼ in. (54 cm.)
Gift of Werner von Grawert, 1902
III C 14966

Stools supported by human figures are important elements in the insignia of Luba rulers. At the investiture of a Luba king or chief, the ruler is seated on such a "throne." Along with other regalia, such as staffs, bowstands, and ceremonial axes, the stool expresses the legitimacy and majesty of his reign. This stool is one of roughly twenty sculptures carved in a distinctive style and considered to be the work of either a single artist or workshop (Olbrechts 1959:71–75). Two sculptures in this style were collected at Buli, a northern Luba town on the Lualaba River, and the style has come to be known as Buli style.

Works in Buli style are characterized by long faces, prominent cheekbones above deep hollows, half-closed eyes set in sunken sockets below arched brows, high rounded foreheads, and bodies that seem emaciated and stooped. Like other Luba sculptures, those in the Buli style depict women with elaborate scarification patterns on their torsos, and both men and women wear ornate hairstyles, a sign of high rank.

Most stools in the Buli style depict a single female figure, either kneeling or standing, but this seat is held aloft by male and female figures, one colored red, the other black. Along with another example in the Landesmuseum in Darmstadt which represents two figures standing back to back (Olbrechts 1959: pls. 126–129), it is among the most accomplished and complex works in this style. HJK/KE

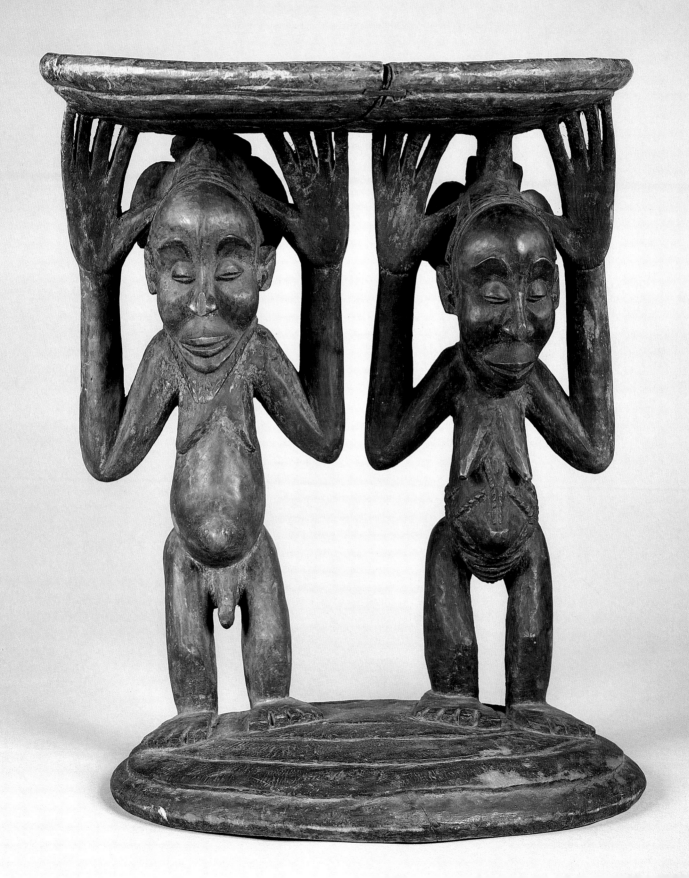

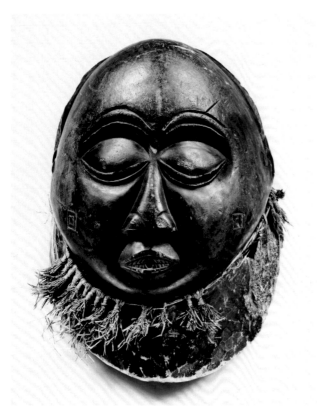

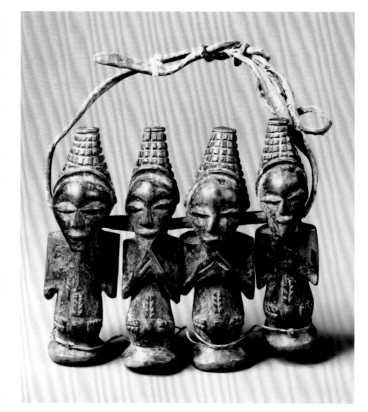

51. MASK
Zaire; Luba, 19th century
Wood, raffia, H. 16½ in. (42 cm.)
Collected by Emin Pasha and Franz
Stuhlmann, 1890 III E 2453

In 1890, this exceptional Luba mask was found in the
East African town of Tabora, several hundred miles
from its place of origin. The late nineteenth century
was a time of intensive commercial activity: Arab trade
caravans passed regularly from the east coast across
Lake Tanganyika to the interior region of Maniema.
Tabora (in present-day Tanzania) was a trading post
situated directly on that route. Emin Pasha (Eduard
Schnitzer), credited as the finder of this mask, was the
Prussian-born governor of the Equatorial Province of
Egypt when war erupted in the 1880s. A relief expedi-
tion led by Henry Morton Stanley escorted the belea-
guered governor to Zanzibar in 1889 (Scott 1890). The
following year, he embarked on his last expedition with
Dr. Franz Stuhlmann. One of their first stops was the
Tabora trade station where they collected this mask
(Stuhlmann 1894).

Luba-Hemba masks are called *kifwebe* to honor a
spirit by that same name. They are worn in male/
female pairs for royal ceremonies (Maes 1924a:36–37)
and on the night of the new moon, when villagers dance
to honor their ancestors. Around the curve of this
mask's head is a band of engraved designs that relate
specifically to Luba kingship and chiefly taboos (Nooter
1990). PN

52. AMULET: FOUR FIGURES
Zaire; Luba, 19th century
Wood, leather, fiber cord, H. 4⅜ in. (11 cm.)
Gift of Hösemann, 1898 III C 8534

53. AMULET: TWO FIGURES
Zaire; Luba, 19th century
Wood, basketry, fiber cords, seeds,
H. 10⅝ in. (27 cm.)
Acquired from Ludwig Wolf, 1886
III C 3624

Among Luba-related peoples, small sculpted figures
are worn or displayed for strength, for luck in hunting,
or for remedying illness. Sometimes they are hidden
within the raffia of dance masks, and they frequently
constitute part of a spirit medium's divining kit (Nooter
1990). One example, cat. no. 52, may have been worn
by a woman during childbirth (Krieger 1965–69,1:fig.
235). Cat. no. 53, identified in the museum's records
as a "house fetish," may have been hung on a wall to
ward away malevolent forces. In both examples, *bwanga*,
medicinal substances that give the charm its potency,
may have been included. Stylistically, the two objects
represent opposite poles of Luba political and artistic
influence. The figures in cat. no. 52, with their high
conical coiffures and the gesture of hands to chin, re-
call Kusu sculpture of the Maniema region to the east,
while those in cat. no. 53 reflect the western style areas
of Luba Kasai or Lulua where Ludwig Wolf, who col-
lected it, is known to have traveled (von Wissmann
1891). These half-figures, called *kakudji*, signal the
importance of the head and torso as loci of personal
strength and action. PN

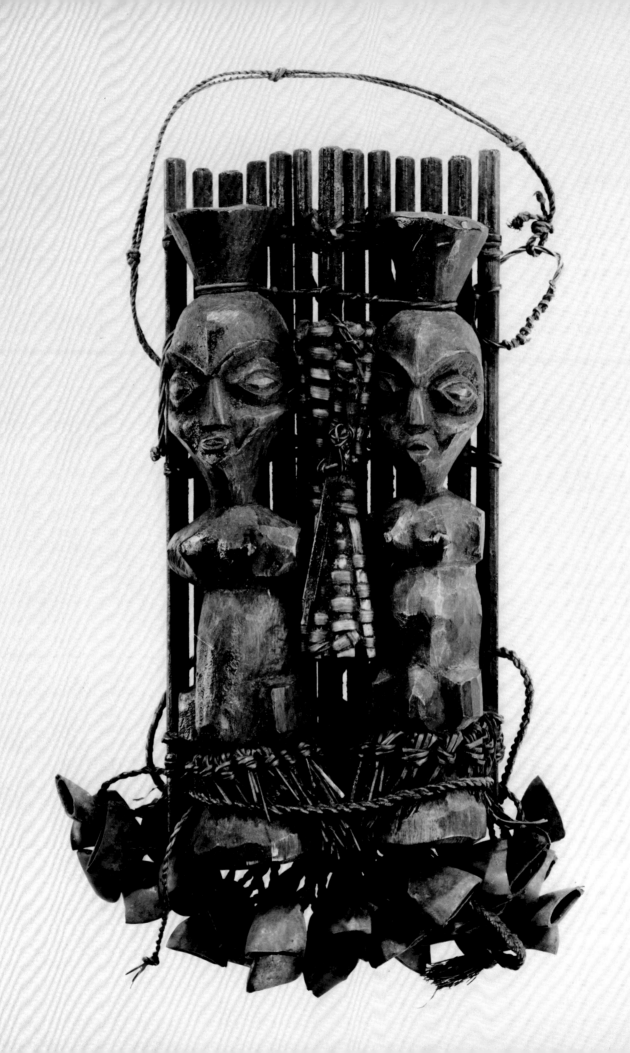

54. Standing Male Figure
Zaire; Hemba, 19th century
Wood, fur, raffia cloth, cord,
H. 31⅞ in. (81 cm.)
Gift of Ramsay, 1897 III E 5200a–c

This commanding object is one of the earliest Hemba
ancestral figures to enter a Western collection. It ar-
rived with a label of "Sanamu," probably a reference
to the ancestor whose honor it upholds. While Hemba
ancestral figures, called *singiti*, are intended as portraits,
they do not reproduce individual traits of the deceased
in a literal way. Rather, through the stylized render-
ings of posture, accoutrements, and insignia, they
portray the social status and ethnic identity of the
individual who fulfilled a leadership role in the com-
munity. Hemba ancestor figures, therefore, convey a
powerful ideological message about family continuity
and perpetuation of the clan (de Strycker 1974–75:98).

Museum records specify that this figure came from
the Niembo peoples of the Luika River. The Bena
Niembo are the dominant Hemba subgroup. The
shape of this figure, with its full rounded forms, bal-
anced symmetrical composition, and oval face with
almond-shaped eyes and aquiline features, places it
in the classic Niembo style grouping (Neyt 1977:87).
In addition to the four-lobed cruciform coiffure,
braided beard, and raffia skirt, the figure originally
wore an imposing parrot-feather headdress reserved
for chiefs (see Olbrechts 1959: pl. 139; Neyt 1977:86–87).
PN

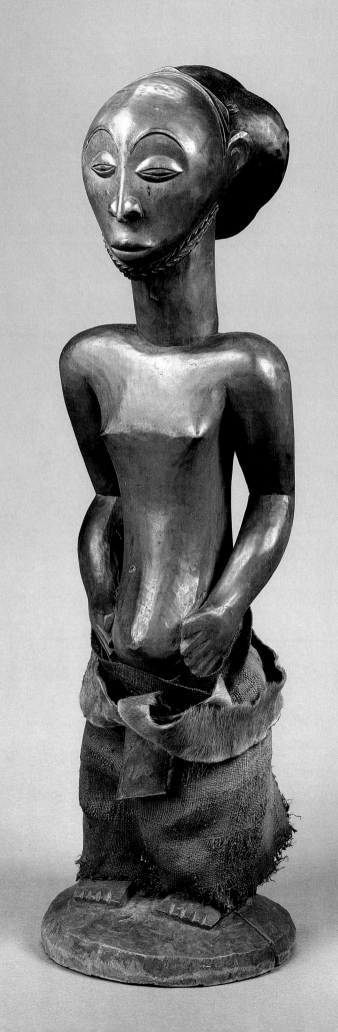

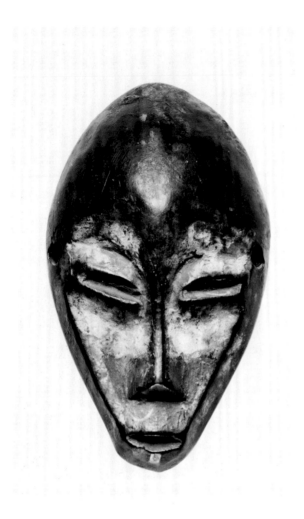

55. MASK

Zaire; Lega, 19th–20th century
Wood, kaolin, H. 5½ in. (14 cm.)
Purchased, 1989 III C 44928

Like almost all Lega carvings, this mask was used by
the powerful *bwami* society, which permeates every as-
pect of life among the Lega. Such small wooden masks,
called *lukwakongo*, are the privilege of the *yananio* mem-
bers, who form the second highest level within *bwami*
(Biebuyck 1985–86, 2: 128–150). It would be replaced
by an ivory version when its owner graduates to a
higher level in the society. In general Lega masks re-
mind their owners of their ancestors, especially recall-
ing their moral principles and exemplary behavior. In
the *bwami* initiation rites, these masks are worn in a
variety of ways: on the forehead, cheeks, or back of
the head, or held in the dignitary's hand as he dances.
At other times they are displayed to the public on fences
or spread on the ground with other ritual objects.
Lukwakongo masks are characterized by a high bulging
forehead that is sharply set off from the concave sur-
face of the face. The face is coated with white kaolin
to give it the "shining" and "clean" appearance valued
in *bwami* objects. HJK/KE

56. MASK

Zaire; Lega, 19th–early 20th century
Wood, fiber, kaolin, H. 10¼ in. (26 cm.)
Purchased from Walther Stahlschmidt, 1921
III C 32944

Large wooden masks, called *muminia* (Biebuyck
1985–86, 2: 161–169), are quite rare. They are found
only in certain Lega lineages, one *muminia* per lineage.
Unlike the smaller Lega wood and ivory masks that
are more widespread but are restricted to only the high-
est levels of *bwami*, the *muminia* masks are required in
the lowest grade of initiation as well as the two high-
est, in all the clans of the lineage, however distant. (The
name *muminia* means "indispensable for initiations"
or "used in many initiations.") The masks are worn on
the head, but during the course of the rituals they can
be moved from the front of the face to the forehead
or top of the head. Although this example has features
typical of Lega masks—the large forehead contrast-
ing with the concave, heart-shaped face, and the bulg-
ing slitted eyes—its strongly projecting mouth is
unusual (part of the lower lip has been restored). HJK/KE

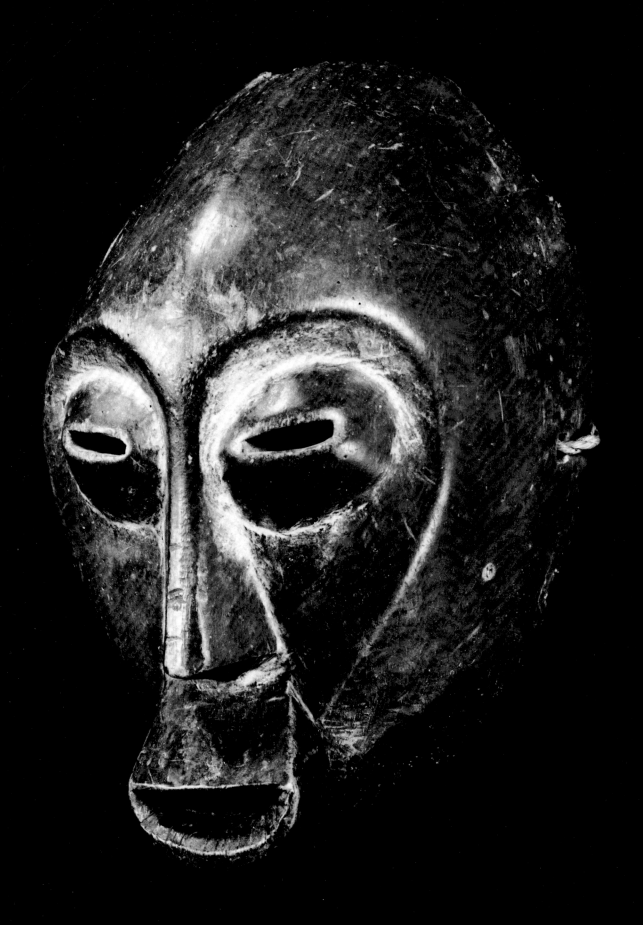

57. FIGURE WITH RAISED ARM
Zaire; Lega, 19th–20th century
Wood, kaolin, H. 13 in. (33 cm.)
Purchased, 1987 III C 44827

Among the Lega, moral principles and social values are taught with the help of art works that are displayed, manipulated, and discussed during initiations into the various levels of the *bwami* society. Figure sculptures in ivory and wood are used at the highest levels of initiation. They portray a series of characters, each representing a type of behavior, either good or bad, that illustrates the lessons of *bwami*. Figures with a raised arm are called Kasungalala (literally "What shoots up straight in the air"). Kasungalala is associated with the phrase "Kasungalala, I have stopped [arbitrated] Igulu [the sky], I have stopped something big," and refers to the responsibility of the highest *bwami* members to serve as arbitrators and peacemakers in quarrels and feuds (Biebuyck 1973: fig. 66; 1985–86, 2:79). The figures are rubbed with oil to give them the smooth shiny surface that to the Lega indicates beauty and goodness in art and in a person's appearance. They may also be coated with kaolin, whose white color similarly represents purity. HJK/KE

58. CONTAINER
Zaire; Mangbetu, 19th century
Wood, bark, H. 25⅝ in. (65 cm.)
Purchased from Leo Frobenius, 1904
III C 19463a–c

The use of anthropomorphic carving as a decorative element on utilitarian objects is known from the first Western descriptions of the peoples of northeastern Zaire and the southern Sudan. Carvings portraying the elongated-head style that was fashionable among the Mangbetu ruling class at the turn of the century were frequently made during the colonial period. These heads, often with representations of face painting, were sometimes said to portray specific individuals. By the first decade of the twentieth century, certain villages in Mangbetu territory had become centers of carving, although the artists were not necessarily Mangbetu. The earliest known anthropomorphic box, made entirely of wood, was collected among the Azande by Wilhelm Junker in the 1880s. This bark one, acquired by the Berlin museum in 1904, is one of the earliest dated examples in the Mangbetu style. Bark boxes were used to store valuables including jewelry and medicines, usually in the form of charms. The box's wooden base is carved in the manner of Mangbetu women's stools (see fig. 5). There is no evidence to suggest that these boxes had ritual significance or were meant to hold ancestral relics. ES

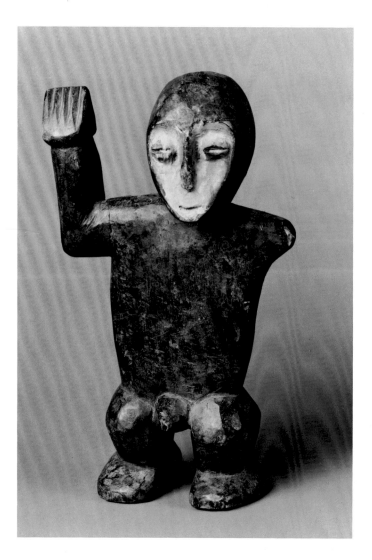

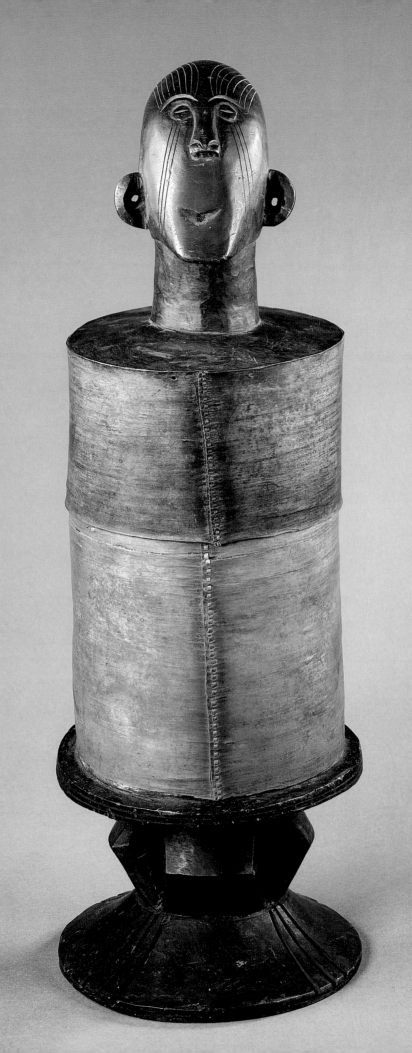

59. FIGURE

Northeastern Zaire, 19th century
Wood, glass beads, animal teeth,
H. 23⅝ in. (60 cm.)
Purchased from Jagd und Kunst, 1911
III C 26772

This figure was probably collected by the Polish ethnographer Jan Czekanowski, who participated in a German ethnological expedition led by Duke Adolf Friedrich zu Mecklenburg to northeast Zaire in 1907/8. Although catalogued in the Berlin museum as Mangbetu, it bears a stylistic resemblance to figures collected among other peoples in the region, notably the Bua, Ngbaka, and Azande. Such figures were probably rare or nonexistent among the Mangbetu before the colonial period. Only one was collected in the region of the Mangbetu, then called Mombuttou, in the nineteenth century (by Emin Pasha and now in the Museum für Völkerkunde, Vienna). Like that figure, the example here may have been made by a carver from one of the many non-Mangbetu groups living within the Mangbetu kingdoms.

Throughout northeastern Zaire, anthropomorphic carving more frequently adorned utilitarian objects, which were coveted by high-status individuals and were given as gifts between rulers, between subjects and rulers, and between African rulers and Europeans. Among peoples living near the Mangbetu, although not among the Mangbetu themselves, carved figures were sometimes placed on graves.

There is evidence to suggest that the Mangbetu admired carved figures as art objects. Czekanowski himself inquired as to the meaning of such figures and wrote: "When I expressed the conjecture that these might be representations of the dead, the people denied it quite firmly. They told me that these were things carved only for pleasure. Nor could I ever observe that these figures were accorded any sort of attention" (Czekanowski 1924:67, quoted in Schildkrout and Keim 1990:237). ES

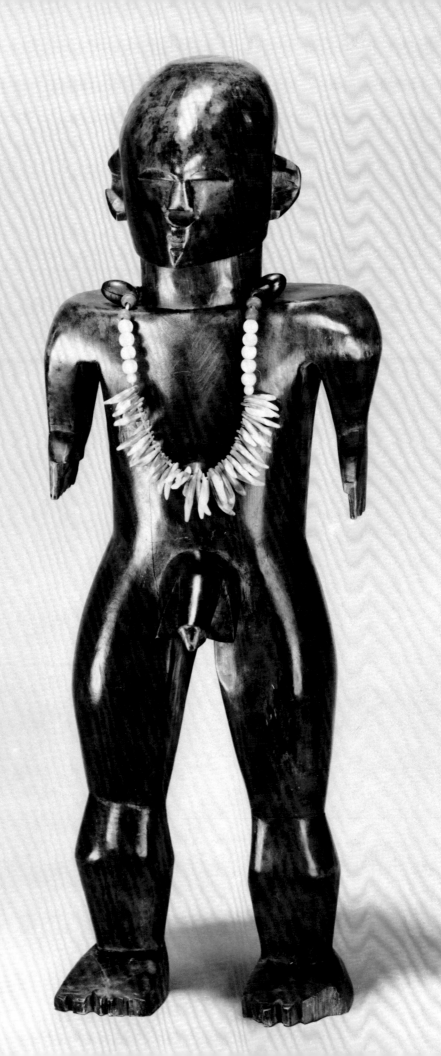

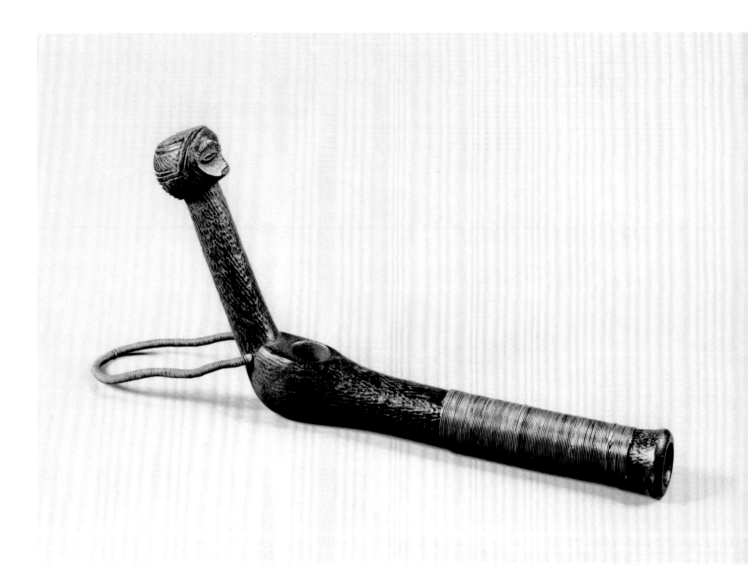

60. PIPE
 Zaire; Ngbaka, 19th century
 Wood, brass, L. 13⅜ in. (34 cm.)
 Purchased from Leo Frobenius, 1904
 III C 19436

61. PIPE
 Zaire; Ngbaka, 19th–20th century
 Wood, brass, iron, pottery,
 H. 12⅝ in. (32 cm.)
 Purchased, 1989 III C 44929

The Ngbaka live on a grassy plateau in northwestern Zaire, southeast of the Ubangi River. They are farmers who migrated into this area from near Lake Chad, to the northwest (Felix 1987:120). Ngbaka masks and figures have strong, simplified forms, characterized by spherical heads with distinctive concave heart-shaped faces. Ngbaka style is evident in these two pipes with human heads. Such pipes are the prerogative of elders and other notables and are often decorated, as in these two examples, with metal strips, tacks, or wire (Burssens 1958:21). Cat. no. 61 exhibits the typical Ngbaka form, in which the bowl emerges from the front of the handle; it is missing the curved metal pipe-stem that would be inserted into a hole in the top of the head. Notches on the forehead and nose depict the raised scarification marks worn by Ngbaka men and women. In cat. no. 60, which is unusual, the carved head would face the smoker as he or she draws upon the mouthpiece at the other end. HJK/KE

78

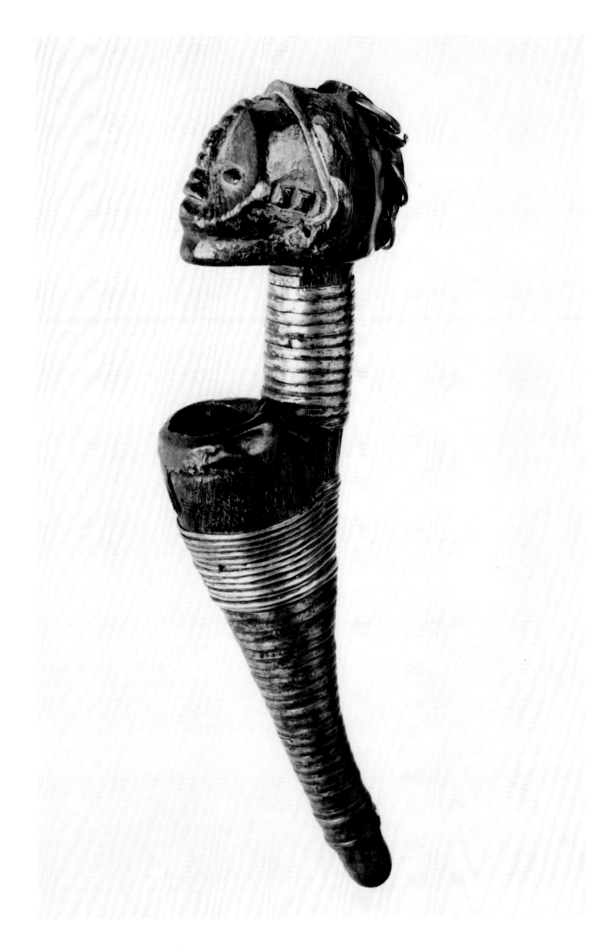

Bibliography

Alexis, M.
1888 *Le Congo Belge illustré*. 2nd ed. Liège.

Ankermann, Bernhard
1906 "Über den gegenwärtigen Stand der Ethnographie der Südhälfte Afrikas." *Archiv für Anthropologie*, n.s. 4:241–86.

Barth, Heinrich
1857–58 *Travels and Discoveries in North and Central Africa: Being a Journal of an Expedition Undertaken under the Auspices of H. B. M.'s Government in the Years 1849–1855*. 5 vols. London.

Bastian, Adolf
1859 *Ein Besuch in San Salvador, der Hauptstadt des Königreichs Congo*. Afrikanische Reisen, 1. Bremen.

1874–75 *Die deutsche Expedition an der Loango-Küste*. 2 vols. Jena.

Bastin, Marie-Louise
1961a *Art décoratif tshokwe*. Lisbon.

1961b "Un masque en cuivre martelé des Kongo du nord-est de l'Angola." *Africa-Tervuren* 7, no. 2:29–40.

1965 "Tshibinda Ilunga: A propos d'une statuette de chasseur ramenée par Otto H. Schütt en 1880." *Baessler-Archiv*, n.s. 13:501–37.

1968 "L'art d'un peuple d'Angola/Arts of the Angolan Peoples, I. Chokwe." *African Arts/Arts d'Afrique* 2, no. 1:40–47, 63–64.

1969 "L'art d'un peuple d'Angola/Arts of the Angolan Peoples, III. Songo." *African Arts/Arts d'Afrique* 2, no. 3:50–57, 70–76.

1976 "Les styles de la sculpture tshokwe." *Arts d'Afrique noire* 19:16–35.

1978 "Statuettes tshokwe du héros civilisateur 'Tshibinda Ilunga'." Supplement to *Arts d'Afrique noire* 19 (1976). Arnouville.

1979 "Art songo." *Arts d'Afrique noire* 30:30–43.

1981 "Quelques oeuvres tshokwe: Une perspective historique." *Antologia di belle arti* 5, no. 17–18:83–104.

1982 *La sculpture tshokwe*. In French and English. Meudon.

1984 *Introduction aux arts d'Afrique noire*. Supplement to *Arts d'Afrique noire* 50. Arnouville.

Baumann, Hermann
1935 *Lunda: Bei Bauern und Jägern in Inner-Angola*. Berlin.

1969 *Afrikanische Plastik und sakrales Königtum: Ein sozialer Aspekt traditioneller afrikanischer Kunst*. Munich.

Biebuyck, Daniel P.
1973 *Lega Culture: Art, Initiation, and Moral Philosophy among a Central African People*. Berkeley and Los Angeles.

1985–86 *The Arts of Zaire*. 2 vols. Berkeley and Los Angeles.

Binkley, David A.
1987a "Avatar of Power: Southern Kuba Masquerade Figures in a Funerary Context." *Africa* 57, no. 1:75–97.

1987b "A View from the Forest: The Power of Southern Kuba Initiation Masks." Ph.D. dissertation, Indiana University, Bloomington, Indiana.

Birmingham, David
1973 "Society and Economy before A.D. 1400." In *History of Central Africa*, edited by David Birmingham and Phyllis M. Martin, pp. 1–29. London.

Boone, Olga
1961 *Carte ethnique du Congo, quart sud-est*. Tervuren.

Bourgeois, Arthur P.
1984 *Art of the Yaka and Suku*. Meudon.

Brincard, Marie-Thérèse, ed.
1989 *Sounding Forms: African Musical Instruments*. Exhibition catalogue, National Museum of African Art, Washington, D.C., and other locations. New York.

Buchner, Max
1886–87 "Kunstgewerbe bei den Negern." *Westermanns illustrierte deutsche Monatshefte* 61:384–96, 514–25.

Burssens, Herman
1958 "La fonction de la sculpture traditionelle chez les Ngbaka." *Brousse* 11:10–28.

Burton, William F. P.
1960 "Notes and Watercolors of Luba Coiffures, 1915–1928/30, Congo Evangelistic Mission, Mwanza." Musée Royal de l'Afrique Centrale, Tervuren.

Cole, Herbert M.
1989 *Icons: Ideals and Power in the Art of Africa.* Exhibition catalogue, National Museum of African Art, Washington, D.C.

Cornet, Joseph
1975 *Art from Zaïre/L'art du Zaïre: 100 Masterworks from the National Collection.* Exhibition catalogue, African-American Institute, New York.

Curnow, Kathy
1989 "Alien and Accepted: African Perspectives in the 15th/16th Century." Paper presented at the 32nd African Studies Association Annual Meeting, Atlanta, Georgia.

Czekanowski, Jan
1924 *Forschungen im Nil-Kongo Zwischengebiet.* Vol. 2, *Ethnographie: Uele, Ituri, Nilländer.* Leipzig.

Einstein, Carl
1920 *Negerplastik.* 2nd ed. Munich.
1921 *Afrikanische Plastik.* Berlin.

Engwall, Ruth
n.d. "An Ethnographic Survey of the Hungana and Related Peoples of the Kwilu Province in the Democratic Republic of Congo." Tervuren.

Fagg, William B.
1964 *Afrika, 100 Stamme—100 Meisterwerke/Africa, 100 Tribes—100 Masterpieces.* Exhibition catalogue, Hochschule für Bildende Künste, Berlin.
1965 *Tribes and Forms in African Art.* New York.

Fagg, William B., and Margaret Plass
1964 *African Sculpture: An Anthology.* London.

Felix, Marc L.
1987 *100 Peoples of Zaire and Their Sculpture: The Handbook for Collectors, Scholars, and Students.* Brussels.

Frobenius, Leo
1898a *Der Ursprung der afrikanischen Kulturen.* Berlin.
1898b *Die Masken und Geheimbünde Afrikas.* Leopoldinisch- Carolinische Deutsche Akademie der Naturforscher, Nova Acta 74, no. 1. Halle.
1907 *Im Schatten des Kongostaates: Bericht über den Verlauf der ersten Reisen der D.I.A.F.E. von 1904–1906* Berlin.
1931 "Die Kunst Afrikas." *Der Erdball* 5. Berlin.
1985–88 *Ethnographische Notizen aus den Jahren 1905 und 1906,* edited by H. Klein. Vol. 1, *Volker am Kwilu und unteren Kassai.* Studien zur Kulturkunde 80, 1985; vol. 2, *Kuba, Leele, Nord-Kete.* Studien zur Kulturkunde 84, 1987; vol. 3, *Luluwa, Sud-Kete, Bena Mai, Pende, Cokwe.* Studien zur Kulturkunde 87, 1988. Stuttgart.

Güssfeldt, Paul
1875a "Bericht über die von ihm geleitete Expedition an der Loango-Küste." *Verhandlungen der Gesellschaft für Erdkunde zu Berlin* 2, no. 1.
1875b "Bericht Dr. Paul Güssfeldts über seine Reise an den Nhanga." *Zeitschrift der Gesellschaft für Erdkunde zu Berlin* 10.
1876 "Zur Kenntnis der Loango-Neger." *Zeitschrift für Ethnologie* 8:203–16.

Haberland, Eike, ed.
1973 *Leo Frobenius, 1873–1973: An Anthology.* Wiesbaden.

Hassert, Kurt
1941 *Die Erforschung Afrikas.* Leipzig.

Henze, Dietmar
1978 *Enzyklopädie der Entdecker und Erforscher der Erde.* Graz.

Hersak, Dunja
1978 Field notes on the Songye, Zaire.
1986 *Songye Masks and Figure Sculpture.* London.

Hibbert, Christopher
1982 *Africa Explored: Europeans in the Dark Continent, 1769–1889.* New York and London.

Hilton, Anne
1985 *The Kingdom of Kongo.* Oxford.

Hoffmann, H.
1979 *Kultur für alle.* Frankfurt am Main.

Jacobson-Widding, Anita
1979 *Red—White—Black as a Mode of Thought: A Study of Triadic Classification by Colours in the Ritual Symbolism and Cognitive Thought of the Peoples of the Lower Congo.* Uppsala.

Junker, Wilhelm J.
1890–92 *Travels in Africa during the Years 1875[–1886].* Translated by A. H. Keane. 3 vols. London.

Kelm, Heinz, and M. Münzel
1974 *Herrscher und Untertanen: Indianer in Peru, 1000 v. Chr.–Heute.* Exhibition catalogue, Museum für Völkerkunde, Frankfurt am Main.

Kerchache, Jacques, Jean-Louis Paudrat, and Lucien Stéphan
1988 *L'art africain.* Paris.

Kjersmeier, Carl
1935–38 *Centres de style de la sculpture nègre africaine.* 4 vols. Paris.

Koloss, Hans-Joachim
1987 *Zaïre: Meisterwerke afrikanischer Kunst*. Exhibition catalogue, Staatlichen Museen Preussischer Kulturbesitz, Berlin.

Krieger, Kurt
1965–69 *Westafrikanische Plastik*. Vols. 1, 3. Berlin.

1973 "Hundert Jahre Museum für Völkerkunde Berlin, Abteilung Afrika." *Baessler-Archiv*, n.s. 21: 101–40.

Krieger, Kurt, and Gerdt Kutscher
1960 *Westafrikanische Masken*. Veröffentlichungen des Museums für Völkerkunde, n.s. 1, Abteilung Afrika, 1. Berlin.

Lamal, F.
1965 *Basuku et Bayaka des districts Kwango et Kwilu au Congo*. Tervuren.

Lecluse, Jean
1985 *Pipes d'Afrique noire*. 2 vols. Liège.

Lehuard, Raoul
1977 "Les Phemba du Mayombe. Supplement to *Arts d'Afrique noire* 17 (1976). Arnouville.

1980 *Fétiches à clous du Bas-Zaïre*. Arnouville.

Leiris, Michel, and Jacqueline Delange
1968 *African Art*. New York.

von Luschan, Felix
1901 *Die Karl Knorrsche Sammlung von Benin-Altertümern im Museum für Länder- und Völkerkunde in Stuttgart*. Stuttgart.

1904 *Anleitung für ethnographische Beobachtungen und Sammlungen in Afrika und Ozeanien*. Berlin.

MacGaffey, Wyatt
1986 *Religion and Society in Central Africa: The Bakongo of Lower Zaire*. Chicago.

1988 "Complexity, Astonishment, and Power: The Visual Vocabulary of Kongo Minkisi." *Journal of Southern African Studies* 14:188–203.

Mack, John
1981 "Animal Representations in Kuba Art: An Anthropological Interpretation of Sculpture." *Oxford Art Journal* 4, no. 2:50–56.

Maes, Joseph
1924a *Aniota-Kifwebe: Les masques des populations du Congo Belge et le matériel des rites de circoncision*. Antwerp.

1924b *Notes sur les populations des bassins du Kasai, de la Lukenie, et du Lac Léopold II*. Annales du Musée du Congo Belge, n.s., Miscelanées 1, no. 1. Brussels.

Maesen, Albert
1959 "Styles et expérience esthétique dans la plastique congolaise." *Problèmes d'Afrique centrale* 44:84–96.

1960 *Umbangu: Art du Congo au Musée Royal du Congo Belge*. Tervuren.

1982a "Statuaire et culte de fécondité chez les Luluwa du Kasai (Zaïre)." *Quaderni Poro* 3:49–58.

1982b Personal communication to Polly Nooter.

1987 Personal communication to Hans-Joachim Koloss.

de Maret, Pierre
1977 "Sanga: New Excavations, More Data, and Some Related Problems." *Journal of African History* 18, no. 3:321–37.

Merriam, Alan P.
1974 *An African World: The Basongye Village of Lupupa Ngye*. Bloomington, Indiana.

Miller, Joseph C.
1969 *Cokwe Expansion, 1850–1900*. Madison, Wisconsin.

Neyt, François
1977 *La grande statuaire hemba du Zaire*. Publications d'histoire de l'art et d'archéologie de l'Université Catholique de Louvain 12. Louvain-la-Neuve.

Nooter, Polly
1984 "Luba Leadership Arts and the Politics of Prestige." M.A. thesis, Columbia University, New York.

1989 "Songs for the Spirit, Remedies for the Soul: The Art of Luba Divination and Healing." Paper presented at the 32nd African Studies Association Annual Meeting, Atlanta, Georgia.

1990 "Sex, Power, and Politics in Luba Dynastic Arts." Paper presented at the College Art Association Annual Meeting, New York.

Forthcoming "Secret Signs in Luba Sculptural Narrative." In *Iowa Studies in African Art: The Stanley Conference at the University of Iowa*, vol. 3. Iowa City.

Olbrechts, Frans M.
1959 *Les arts plastiques du Congo Belge*. Brussels.

Oliver, Roland, and Brian M. Fagan
1978 "The Emergence of Bantu Africa." In *The Cambridge History of Africa*, edited by J. D. Fage, vol. 2:342–409. Cambridge.

van Overbergh, Cyr.
1908 *Les Basonge: Sociologie descriptive*. Collection de monographies ethnographiques 3. Brussels.

Paris, Fondation Dapper
1988 *Art et mythologie: Figures tshokwe*. Exhibition catalogue, Musée Dapper, Paris.

Pechuël-Loesche, Eduard
1907 *Volkskunde von Loango.* Stuttgart.

Pigafetta, Filippo
[1591] 1969 *A Report of the Kingdom of Kongo and of the Surrounding Countries; Drawn out of the Writings and Discourses of the Portuguese, Duarte Lopez.* Translated by M. Hutchinson. Reprinted from the 1881 London ed. New York. First published Rome, 1591.

Pogge, Paul
1880 *Im Reiche des Muata Jamwo.* Berlin.

Preston, George N., Susan M. Vogel, and Polly Nooter
1985 *Sets, Series, and Ensembles in African Art.* Exhibition catalogue, Center for African Art, New York.

Ratzel, Friedrich
1887–90 *Völkerkunde.* 3 vols. Leipzig.

Richards, Audrey I.
1935 "Bow Stand or Trident?" *Man* 35 (February): 30–32.

Robbins, Warren M., and Nancy Ingram Nooter
1989 *African Art in American Collections: Survey 1989.* Washington, D.C.

Rumpf, Angelika, and Irwin L. Tunis
1984 "Berlin: Museum für Völkerkunde." *Critica d'arte africana,* ser. 2, 1 (Spring supplement): 17–28.

Schachtzabel, Alfred
1923 *Im Hochland von Angola: Studienreise durch den Süden Portugiesische-West-Afrikas.* Dresden.

Schildkrout, Enid, and Curtis Keim
1990 *African Reflections: Art from Northeastern Zaire.* Exhibition catalogue, American Museum of Natural History, New York. Seattle.

[Schnitzer, Eduard] Emin-Bey
1880 "Dr. Emin Beys Reise nach der Westseite des Albert-Sees." *Petermann's Mitteilungen* 26:263.

Schütt, Otto H.
1881 *Reisen im südwestlichen Becken des Congo.* Berlin.

Schweinfurth, Georg A.
1873 *The Heart of Africa: Three Years' Travel and Adventures in the Unexplored Regions of Central Africa, from 1868 to 1871.* Translated by Ellen E. Frewer. 2 vols. London.

Schweinfurth, Georg A., et al., eds.
1889 *Emin Pasha in Central Africa: Being a Collection of His Letters and Journals.* Translated by Mrs. R. W. Felkin. New York.

Scott, E. P.
1890 *Stanley and His Heroic Relief of Emin Pasha.* London.

Sieber, Roy, and Roslyn Adele Walker
1987 *African Art in the Cycle of Life.* Exhibition catalogue, National Museum of African Art, Washington, D.C.

Siroto, Leon
1976 *African Spirit Images and Identities.* Exhibition catalogue, Pace Gallery, New York.

Söderberg, Bertil
1966 "Antelope Horn Whistles with Sculptures from the Lower Congo." *Ethnos* 31:5–33.

1974 "Les sifflets sculptés du Bas-Congo." *Arts d'Afrique noire* 9:25–44.

von den Steinen, Karl
1905 "Gedächtnisrede auf Adolf Bastian." *Zeitschrift für Ethnologie* 37:236–49.

de Strycker, Louis
1974–75 "La statuaire hemba du culte des ancêtres. Eléments de différenciation des Hemba par rapport aux Luba-Hemba." Mémoire de licence, Institut International de Catéchèse et de Pastorale de Bruxelles, Brussels.

Stuhlmann, Franz
1894 *Mit Emin Pascha ins Herz von Afrika.* Berlin.

von Sydow, Eckart
1923 *Die Kunst der Naturvölker und der Vorzeit.* Propyläen Kunstgeschichte 1. Berlin.

1926 *Kunst und Religion der Naturvölker.* Oldenburg.

1930 *Handbuch der westafrikanischen Plastik.* Vol. 1 of *Handbuch der afrikanischen Plastik.* Berlin.

1954 *Afrikanische Plastik.* Edited by Gerdt Kutscher. New York.

Theuerkauff, Christian
1985 "The Brandenberg Kunstkammer in Berlin." In *The Origins of Museums,* edited by Oliver Impey and Arthur MacGregor, pp. 110–14. Oxford.

Thiel, Josef F., and Heinz Helf
1984 *Christliche Kunst in Afrika.* Berlin.

Thomas, Thérèse
1960 "Les itombwa, objets divinatoires sculptés conservés au Musée Royal du Congo Belge." *Congo-Tervuren* 6, no. 3:78–83.

Thornton, John K.
1983 *The Kingdom of Kongo: Civil War and Transition, 1641–1718.* Madison, Wisconsin.

Timmermans, Paul
1966 "Essai de typologie de la sculpture des Bena Luluwa du Kasai." *Africa-Tervuren* 12, no. 1:17–27.

Torday, Emil
1910 "Land and Peoples of the Kasai Basin." *Geographical Journal* 36:26–57.

Torday, Emil, and Thomas A. Joyce
1910 *Notes ethnographiques sur les peuples communément appelés Bakuba, ainsi que sur les peuplades apparentées: Les Bushongo.* Annales du Musée du Congo Belge, ser. 3 [4]: Ethnologie et anthropologie 2. Brussels.

1922 *Notes ethnographiques sur des populations habitant les bassins du Kasai et du Kwango Oriental.* Annales du Musée du Congo Belge, ser. 3 [4]: Ethnologie et anthropologie 3. Brussels.

Van Geluwe, Huguette
1978 "Phemba Mother with Child." In *Vingt-cinq sculptures africaines/Twenty Five African Sculptures,* edited by Jacqueline Fry, pp. 147–51. Exhibition catalogue, National Gallery of Canada, Ottawa.

1982 Verbal communication to Polly Nooter.

Vansina, Jan
1955 "Initiation Rituals of the Bushong." *Africa* 25, no. 2:138–53.

1958 "Les croyances religieuses des Kuba." *Zaire* 12:725–58.

1978 *The Children of Woot: A History of the Kuba Peoples.* Madison, Wisconsin.

1984 *Art History in Africa: An Introduction to Method.* London.

Vogel, Susan M.
1980 "The Buli Master, and Other Hands." *Art in America* 68, no. 5 (May):133–42.

Wannyn, Robert L.
1961 *L'art ancien du métal au Bas-Congo.* Champles par Wavre.

Weeks, John H.
1914 *Among the Primitive Bakongo: A Record of Thirty Years' Close Intercourse with the Bakongo and Other Tribes of Equatorial Africa, with a Description of Their Habits, Customs, and Religious Beliefs.* Philadelphia.

Weyns, Joseph A.
1960 "Contribution à l'étude du complexe stylistique Ba-Yaka—Ba-Suku (Kwango, Congo Belge)." Congrès International des Sciences Anthropologiques et Ethnologiques, *Compte-rendu de la troisième session, Bruxelles, 1948:275.*

von Wissmann, Hermann
1890a *Unter deutscher Flagge quer durch Afrika von West nach Ost; von 1880 bis 1883 ausgeführt von Paul Pogge und Hermann [von] Wissmann.* 6th ed. Berlin.

1890b *Meine zweite Durchquerung Äquatorial-Afrikas vom Congo zum Zambesi während der Jahre 1886 und 1887.* Frankfurt an der Oder.

1891 *My Second Journey through Equatorial Africa from the Congo to the Zambese, in the Years 1886 and 1887.* Translated by Minna J. A. Bergmann. London.

1902 *Unter deutscher Flagge quer durch Afrika von West nach Ost; von 1880 bis 1883 ausgeführt von Paul Pogge und Hermann von Wissmann.* 8th ed. Berlin.

von Wissmann, Hermann, et al.
1891 *Im Innern Afrikas: Die Erforschung des Kassai während der Jahre 1883, 1884, und 1885.* Leipzig.

Zwernemann, Jürgen
1961 "Spiegel- und Nagelplastiken vom unteren Kongo im Linden-Museum." *Tribus* 10:15–32. Stuttgart.

1987 "Leo Frobenius und das Hamburgische Museum für Völkerkunde." *Mitteilungen aus dem Museum für Völkerkunde Hamburg,* n.s. 17:111–27.

Appendix

Publication History of the Objects

1. Power Figure: Standing Man (Congo, Loango; Kongo): Ankermann 1906: pl. 35, fig. 1; Krieger 1965–69, 1: no. 254, fig. 213; Lehuard 1980:107

2. Power Figure: Standing Man (Congo; Vili): Krieger 1965–69, 1: no. 224, fig. 193; Koloss 1987: no. 7, pl. 3

3. Power Figure: Standing Man (Congo, Loango; Vili): Bastian 1874–75, 2: pl. following 353; Krieger 1965–69, 1: no. 213, fig. 183; Koloss 1987: no. 6, pl. 2

4. Power Figure: Kneeling Woman (Congo, Loango; Kongo): Krieger 1965–69, 1: no. 210, fig. 180; Koloss 1987: no. 8, fig. 6

5. Standing Female Figure (Congo and Zaire; Kongo): von Sydow 1954: pl. 60A; Krieger 1965–69, 1: no. 255, fig. 214

6. Kneeling Woman and Child (Congo and Zaire; Yombe): Einstein 1920: fig. 64; Krieger 1965–69, 1: no. 209, fig. 179; Lehuard 1977:47; Koloss 1987: no. 9, fig. 7

7. Mask (Congo; Vili): von Sydow 1954: pl. 64B; Krieger and Kutscher 1960: no. 151, fig. 65

8. Whistle: Animal (Congo and Zaire; Sundi): Krieger 1965–69, 1: no. 253, fig. 212B

9. Whistle: Monkey (Congo; Vili): Krieger 1965–69, 1: no. 250, fig. 211A; Söderberg 1966: fig. 13; Koloss 1987: no. 12, fig. 4A

10. Whistle: Bird (Congo; Sundi): Krieger 1965–69, 1: no. 248, fig. 210A; Söderberg 1966:28

11. Whistle: Man (Congo and Zaire; Sundi): Krieger 1965–69, 1: no. 249, fig. 210B; Söderberg 1966:16; Söderberg 1974:43

12. Whistle: Man (Congo, Loango; Kongo): Krieger 1965–69, 3: no. 158, fig. 166

13. Crucifix (Congo and Zaire; Kongo): Koloss 1987: no. 1, fig. 2B

14. Ivory Plaque with Christ and Kneeling Figures (Congo, Pointe Noire; Vili): Krieger 1965–69, 3: no. 159, fig. 167; Thiel and Helf 1984:108; Koloss 1987: no. 3, fig. 2A

15. Toni Malau: Saint Anthony with Christ Child (Congo and Zaire; Kongo): Koloss 1987: no. 2, pl. 2

16. Carved Elephant Tusk (Congo, Loango; Vili): Bastian 1874–75, 1: folding endplate; Krieger 1965–69, 3: no. 154, fig. 162; Koloss 1987: no. 5, fig. 3A, B

17. Hammock Peg: Man (Congo, Loango; Kongo): Krieger 1965–69, 3: no. 157, fig. 165

18. Hammock Peg: Monkey (Angola, Ambriz; Kongo): Krieger 1965–69, 3: no. 156, fig. 164

20. Power Figure (Zaire; Hungaan): von Sydow 1954: pl. 72C; Fagg 1965: no. 87; Krieger 1965–69, 1: no. 267, fig. 224; Kerchache, Paudrat, and Stéphan 1988: fig. 765

23. Female Mask, Ngady mwaash (Zaire; Kuba): Krieger and Kutscher 1960: no. 158, fig. 70

24. Male Mask, Mulwalwa (Zaire; Southern Kuba): von Sydow 1954: pl. 80A,B; Krieger and Kutscher 1960: no. 159, fig. 71

25. Palm-wine Cup: Standing Figure (Zaire; Kuba): Krieger 1965–69, 3: no. 196, fig. 205; Koloss 1987: no. 16, fig. 10

26. Palm-wine Cup (Zaire; Wongo): Krieger 1965–69, 3: no. 218, fig. 230; Koloss 1987: no. 17, fig. 11B

27. Friction Oracle (*itoom*; Zaire; Kuba): Krieger 1965–69, 1: no. 297, fig. 250B

29. Hunter (Angola; Chokwe): Schütt 1881:131; Alexis 1888:233; von Sydow 1954: pl. 96A; Bastin 1965: figs. 9–11; Krieger 1965–69, 1: no. 322, fig. 268; Leiris and Delange 1968:36; Baumann 1969: pl. 11; Siroto 1976:14; Bastin 1978: pl. 3; Bastin 1981:91–92; Bastin 1982: no. 80; Vansina 1984:104; Koloss 1987: no. 36, cover; Paris, Fondation Dapper 1988:72; Cole 1989: fig. 114

30. Standing Woman (Angola; Chokwe): von Sydow 1926: pl. 23; Fagg 1964: fig. 76; Krieger 1965–69, 1: no. 306; Bastin 1981:95–96; Bastin 1982: no. 97; Koloss 1987: no. 38, fig. 22; Paris, Fondation Dapper 1988:9

31. Woman with Containers of Food (Angola; Chokwe): von Sydow 1930: pl. 8, fig. 12; Krieger 1965–69, 1: no. 305, fig. 257; Bastin 1968: fig. 13; Bastin 1978: fig. 2; Bastin 1981:93–94; Bastin 1982: no. 98; Koloss 1987: no. 39, fig. 23; Paris, Fondation Dapper 1988:57

32. Figure (Angola; Chokwe): Baumann 1935:196, pls. 86, 92; Krieger 1965–69, 1: no. 309, fig. 260; Bastin 1982:159